Art Activities
from
Award-Winning
Picture Books

Written and illustrated
by Judy Hierstein

Teaching & Learning Company

1204 Buchanan St., P.O. Box 10
Carthage, IL 62321

This book belongs to

Cover photo by Images and More Photography

Copyright © 1995, Teaching & Learning Company

ISBN No. 1-57310-034-X

Printing No. 9876543

Teaching & Learning Company
1204 Buchanan St., P.O. Box 10
Carthage, IL 62321

Table of Contents

Dear Teacher,

With the elementary art teacher becoming an endangered species, the classroom teacher is frequently expected to provide her students with the only art the class may have. The whole language approach extends the enjoyment of the great literature being read in the classrooms with creative art projects.

While teaching elementary art, I have found that one of the most effective ways of presenting an art lesson is using picture books. There is no easier way to hold a class' attention than reading them a story, and with the profusion of books available in this "Golden Age of Children's Literature," it is not difficult to find just the right one to fit your needs—it is most likely already in your classroom or school library—and leave your students eager to begin work.

Children's books today are illustrated with superb art, often reflecting current trends in the art world or emulating the artistic style of the period when the story takes place or the ethnic style of the culture where it takes place. Students are exposed to fine art, perhaps the first time, in these books. The art is usually researched in great detail for authenticity, filled with visual side stories, foreshadowing and secret detail (often humorous) much of which may be discovered only after repeated viewings.

Each year since 1938, the American Library Association presents the Caldecott Medal, named after Randolph Caldecott, a reknowned nineteenth century English children's book illustrator, to the "artist of the most distinguished American picture book for children." In addition to the award-winning book, one or more Honor Books may also be recognized if the association deems them worthy.

In this book, I have selected my favorite picture books from among Caldecott Medal winners and Honor Books and created solid art extension activities which have proven successful in my artroom and could be easily used by the classroom teacher. Each activity begins with information about the picture book—a brief summary of the text and the illustrations. Then an art activity is presented, complete with a list of materials required, step-by-step illustrated directions, the art concepts and techniques involved, and tips on arranging the finished products into effective displays. I've designed these activities so that they utilize classroom supplies normally on hand. In most cases, the integrity of the lesson will not be damaged if substitutions are made. Also included are tips on acquiring materials free or inexpensively, and recipes for homemade art materials such as egg carton clay.

Sincerely,

Judy

Judy Hierstein

Materials, Sources, Recipes

Our community has a program called WasteSHARE, whose mission is to recycle materials that businesses and industries would throw away, making these materials available to teachers free of charge. The school system has provided space in their maintenance building and teachers go there during specified hours and help themselves, free of charge. The director receives a salary for which she contacts businesses, collects and stores materials, and keeps track of what is utilized so reports can be prepared to satisfy the grant which funds the program. When the grant runs out, each school system in the area served by WasteSHARE will be asked to pay $1.00 per student for continued use of the facility to cover the director's salary. Everyone agrees it is a great program, especially teachers who can enrich their curriculum without impoverishing themselves.

At the beginning of each year, usually during Open House, I send a letter to the parents asking them to save any supplies we may use. My list of suggested supplies includes: cardboard toilet paper and paper towel rolls, Styrofoam™ trays, old greeting cards–especially holiday cards because they often have shiny surfaces, used fabric softener sheets for the dryer (to make tutus for ballet puppets and wrinkly elephant skin), plastic containers and plastic egg cartons. (The last items make perfect tempera containers. Each table gets a small amount of each color in a carton, and at the end of the project, there is not enough left of the mixed-up colors to clean up. Empty egg-depressions or additional cartons work well for mixing colors–sometimes the used egg cartons are as artistic as the finished work! Egg cartons also make great bumpy caterpillars when painted.)

- Most home decorating shops are happy to give away wallpaper sample books once they are out-dated and new ones have come in. Stop by and leave your name and phone number so the owner can call you when books are available. Wallpaper samples are easier for young students to cut than fabric, yet they provide the same visual excitement as printed cloth does, and wallpaper is even better when it is the foil type because it shines.

- Our local mall conducts many promotions throughout the year with posters printed on heavy expensive poster board and sometimes foamcore board. Once the promotion is over, the posters are useless to the mall so they are happy to donate them to our school. These cut to any size with the paper cutter and take tempera paint well. You can make everything from medieval shields to African masks to bases for three-dimensional scenes.

- I have students bring Styrofoam™ meat trays from home. They make excellent containers for storing scissors, crayons and other supplies. They also can be used for printmaking. Even the youngest students can safely cut and press lines into the soft surface using pencils. Just be sure the trays are washed to avoid contamination from previous contents.

- There are several large printing firms in our area who are willing to give us paper scraps, which are sometimes quite large and usually much higher quality than school-grade paper. They can be cut on a paper cutter to fit your requirements.

- Before I throw anything away, I consider whether I may be able to use it on an art project. This especially includes shiny things such as aluminum foil, gold chocolate wrappers, foil mylar packaging, gift wrap and ribbons, and foil-embossed holiday greeting cards. These can be cut into small pieces to add the touch of sparkle to many projects that students love so well.

Recipes

Cooked Dough

 1 c. (240 ml) flour

 ½ c. (120 ml) salt

 1 c. (240 ml) water

 2 tsp. (10 ml) cream of tartar

 1 T. (15 ml) vegetable oil

 food coloring (optional)

Combine ingredients and cook over medium heat, stirring constantly, especially when mixture begins to thicken. Turn out onto waxed paper and cover with plastic until dough is cool enough to handle. Keep inside plastic bag to prevent drying. Food coloring may be added with the other ingredients (less messy) or kneaded in at anytime after the clay is prepared (greater variety of colors).

Salt Clay

 1 c. (240 ml) salt

 1 c. (240 ml) flour

 1 T. (15 ml) alum

 food coloring (optional)

Mix with enough water to form clay or putty consistency. Keep in plastic bags to prevent drying. Food coloring may be added, but it is better to paint sculpture after it has dried.

Chunky Egg Carton Clay

Tear paper egg cartons into 1" (2.5 cm) small pieces and soak overnight in a large plastic container. Drain and squeeze out all excess moisture; then pour in white glue and mix with hands until mixture is the consistancy of clay. This clay works well for lunar and terrestrial landscapes.

Smooth Egg Carton or Newspaper Clay

If a smoother consistency of clay is required for forming dragons or finger puppets, place egg carton pieces or wet strips of newspaper in an old blender until it is half full. Add enough water to cover. Pulverize, then drain through a colander, squeeze to remove all excess moisture and mix with white glue until the consistency of clay is achieved. (On occasions when I have needed a little extra clay quickly, I have unrolled toilet paper, dampened it and added the white glue.) With any of these materials, the resulting clay sticks well to cardboard rolls or boxes which may be incorporated into the sculpture, and takes tempera paint beautifully once dry. There is a commercial product on the market called Celluclay™ to which you merely add water. It is a lot less work but more expensive.

To Begin

I always begin class by having the children sit in a semicircle in the center of the room, half on chairs, and the rest directly in front of them on the floor. This way they can all see as I read the story and demonstrate the project. I have the tables ready with all necessary supplies so the students can go right to work as soon as the lesson is presented, but they are not tempted to fiddle with anything instead of listening. I place everything I need to present the lesson–the book, supplies and finished examples–on a large sheet of paper or poster board in the center of the circle. Sometimes I cover it all up so the surprise will not be spoiled.

Before I read the story to the children, I tell them the author and, of course, the illustrator. They all know what *illustrator* means. I ask them how they think this artist made these pictures. At first they all say "paint," but in time, they look very carefully and become good at spotting cut paper, or chalk, or watercolors, especially after they have had some experience working with the medium. Once I asked them how they thought the artist made Miss Spider's eye look

wet, and they all thought he surely used wet paint! But with coaxing, even the little ones could see the white reflections and they then had to check their classmates' eyes to see if this phenomenon always occurred.

I am also very careful to stress that everyone's artwork will look different from mine and his classmate's because each artist must express herself differently. I can't wait to see all the creative ideas they will come up with.

Each class each year seems to have its own unique personality and abilities. The activities suggested in this book can be altered to meet your specific class needs. You know your class best. You may want to simplify an activity by using crayons instead of paint or tracing shapes for those students who may become frustrated if faced with this task. There are also natural breaks in many of the activities so that they can be completed in small segments. The main objective is to challenge every student, but keep the activity a joyful, positive experience.

Make Way for Ducklings

Illustrated and written by Robert McCloskey. Viking, 1941. Caldecott, 1942.

Story Summary

Mr. and Mrs. Mallard are searching for a safe and suitable place to raise a family. They fly over Boston with its many sights and finally settle on a small island along the Charles River. It is not far from the Public Gardens where they have been fed peanuts by the people floating in the swan boats on the pond there. Their family hatches from the eight eggs Mrs. Mallard has laid, and she undertakes their training. When they decide to take an excursion to the Public Gardens (for the peanuts), they encounter such heavy traffic that they must be rescued by their friend, policeman Michael, who stops traffic and radios ahead for his fellow cops to do the same until the family of ducks arrive safely at their destination–where they decide to stay.

Illustrations and Comments

Though printing is far more technologically advanced than it was when McCloskey created these lithographs, they are still appealing. Anyone who has visited the Boston area will recognize the landmarks used in this story.

Materials

brown construction paper or paper bags
white 12" x 18" (30 x 46 cm) paper
scissors
crayons

Art Activity

Ducklings in Your Backyard

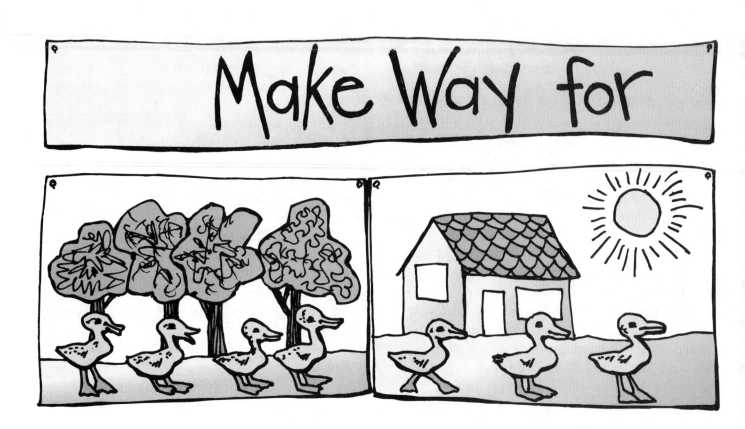

Directions

After reading the story, go back through it taking special note of the background. Explain that the artist did not make these places up, but that he went to Boston (years ago) with his sketch pad and drew what he saw in front of him. Ask the children to think of a place they know that would make a good setting for the story–maybe their front yard, down the block or even the school playground. If possible, take the class outside with 12" x 18" (30 x 46 cm) white paper and have them draw the scene before them with one color only, such as black, blue or brown. When students return to class, have them add a row of ducklings across the bottom edge of each picture. Cut them from brown construction paper or brown paper bags and color the beaks and feet orange and the breasts white. These can be produced a few at a time by folding the paper first, since they are all exactly the same size. Have the students think of rhyming names for the ducklings as the author did, and label each one as it is glued onto the artwork.

Display

Display the drawings end to end so that there appears to be one phenomenally long row of ducklings. Cut one large mother duck from brown construction paper, add color details and have her lead the row. Glue 6" x 18" (15 x 46 cm) strips of paper end to end and write the title "Make Way for Ducklings" in the same blue or brown crayon the children used for their drawings. Display it above the artwork.

Related Artists

Georges Seurat (waterside scenes)
Peter Bruegel (crowds of everyday people)

Art Concepts and Techniques

Drawing from life
Repetition
Seeing detail
Cutting

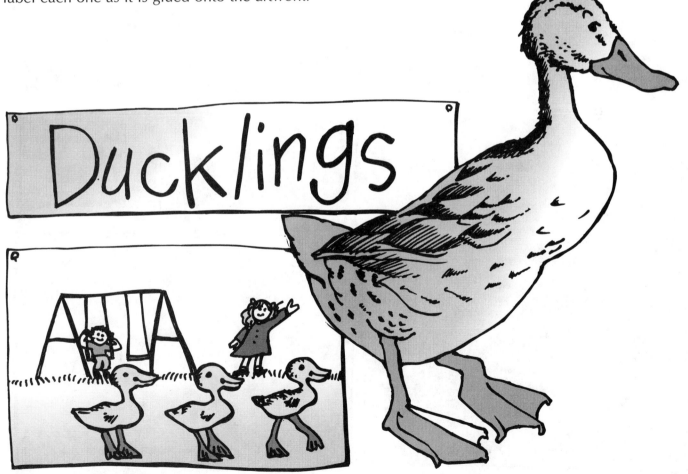

The Little House

Illustrated and written by Virginia Lee Burton. Houghton Mifflin, 1942. Caldecott, 1943.

Story Summary

Once upon a time there was a little house way out in the country. Progress slowly brings the big city to the little house and crowds her between skyscrapers until she can no longer see the sun except at noon, and she falls into disrepair. One day the great-great granddaughter of the man who built the house finds her and rescues her by moving her way out into the country once again.

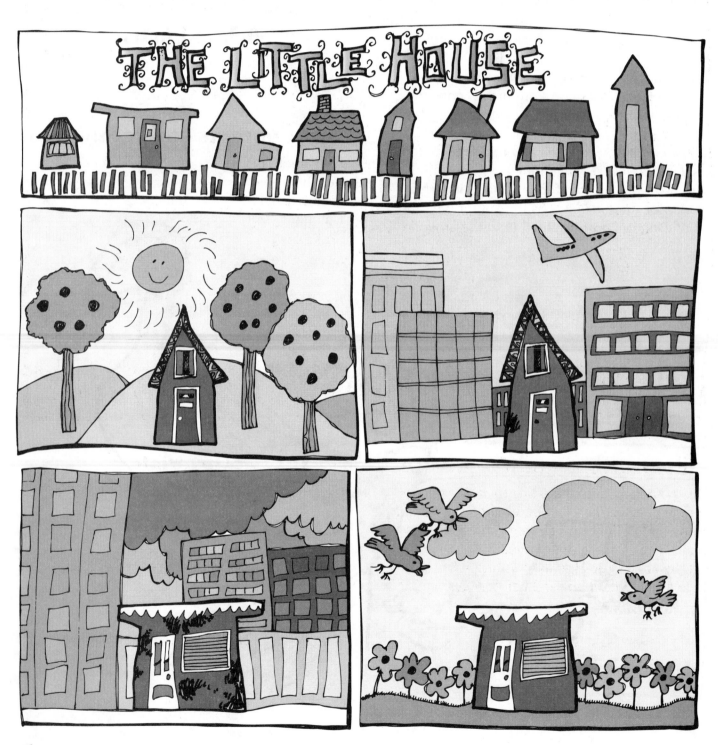

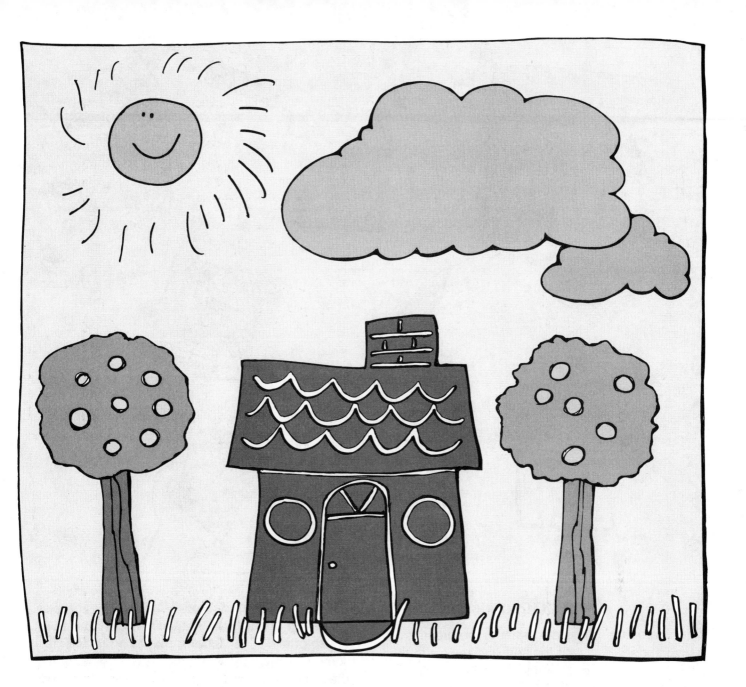

Illustrations and Comments

This book was one of the first to make a social comment to young children about big cities and grime and pollution. The personified little house begins with a smile and gradually becomes sad, but the artist keeps her in the same spot on each page as everything around her changes.

Art Activity

The Little House Changes

Materials

large white paper
scissors
pencils
crayons
Styrofoam™ meat trays (some with the edges removed so that only the flat bottom remains–I use a paper cutter for this)
brayers (brushes could substitute)
tempera paint or block printing ink
newspaper

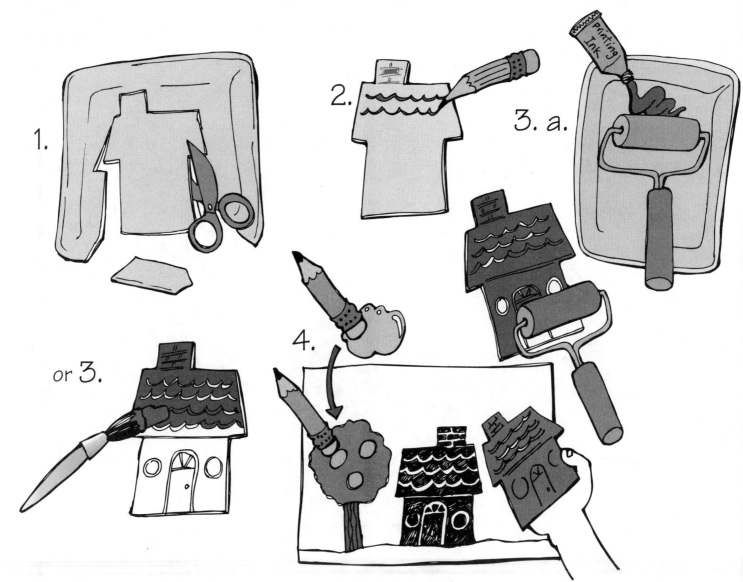

Directions

After reading the book, discuss how the pictures change and the fact that the house is always in the same place. Introduce the block printing technique. Have students draw their own house on a flat piece of Styrofoam™, pressing firmly with a blunt pencil, then cut around the outside to make a house-shaped block for printing. In another Styrofoam™ plate with 1" (2.5 cm) edges, pour a small amount of tempera (or squeeze a little printer's ink) and roll the brayer back and forth to spread it; then roll the brayer over the block to cover it with an even layer of paint. The printer's ink will be stickier and work better, but it is expensive and the printing process can still be experienced using tempera paint. Even if your classroom does not have brayers, students can use large brushes to apply tempera to their block. Place block facedown near the bottom center of the paper which has been padded with several layers of newspaper. Repeat this process on a second sheet of paper so that each student has two house prints. The students may want to blend some muddied colors on the second print to make the house look dirty and unloved. Now let each student design "before" and "after" versions of the little house. Some may wish to cut a tree block and print many green trees, adding apples by dipping the eraser end of a pencil in red and printing over the green. Suns, birds and flowers are also options. The second house will need big buildings overwhelming it, so large square Styrofoam™ blocks with many windows must be made. Encourage the students to swap their blocks with their neighbors once they have finished with them to add more variety to each work of art. To simplify this project for lower grades, once the two house prints are dry, have students add the details of the "before" and "after" pictures with crayons instead of cutting additional Styrofoam™ blocks.

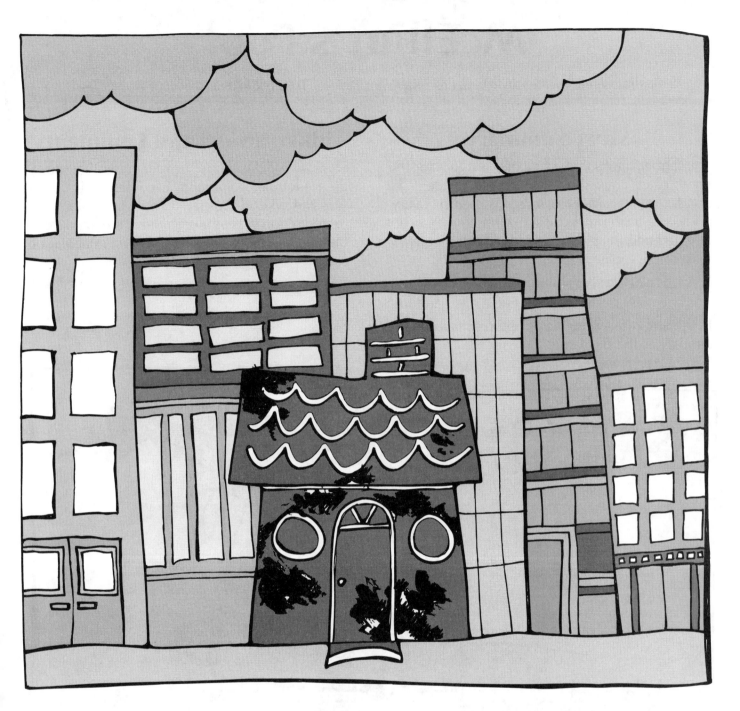

Display

Have each student print their house a third time along the bottom edge of a long sheet of paper. Use the edge of a sponge dipped in green tempera to print grass beneath the house. Use another sponge dipped in black tempera to write "The Little House" in the sky (see page 6).

Related Artists

Thomas Hart Benton
Grant Wood (for the rolling scenery)

Art Concepts and Techniques

Block printing
Repetition of shapes
Drawing
Cutting

McElliot's Pool

Illustrated and written by Dr. Seuss. Random House, 1947. Caldecott Honor Book, 1948.

Story Summary

The farmer thinks the young boy is a fool for trying to catch any fish in such a measly little pond. Anyway, McElliot's Pool is used by everybody as a trash dump. But the young man is not deterred and imagines all kinds of fish that he may catch, including:

"A fish that's so big, if you know what I mean,
That he makes a whale look like a tiny sardine!"

In the end, this young boy's optimistic attitude almost has the old farmer convinced.

Illustrations and Comments

Dr. Seuss' illustrations are so familiar that they do not require comment. Even though this book was written and illustrated while full-color art reproduction was still prohibitively expensive, the crazy illustrations still make the imagination soar.

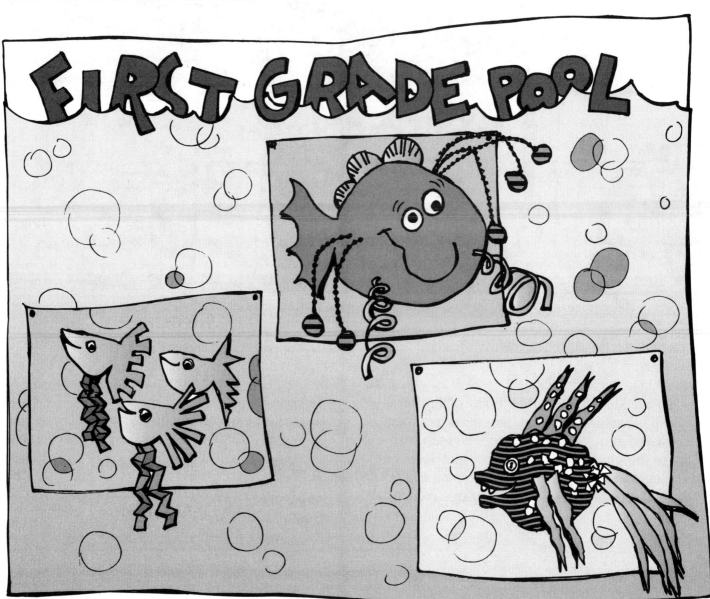

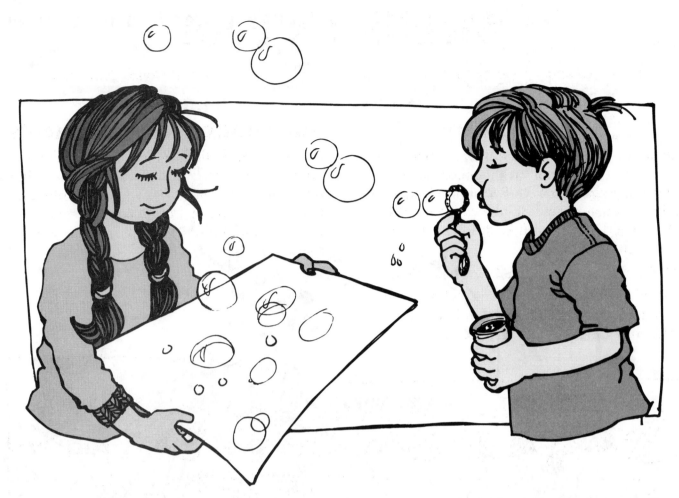

Directions

When the class has finished enjoying the book, discuss some of the weird fish that Dr. Seuss included in this story. Which ones are real? Make-believe? Which ones do the children think are the silliest? Have them think of their own imaginary fish while they make their background in the following manner. Add a few drops of food coloring to some soap bubbles and have the students "catch" the bubbles on their paper. If they hold it horizontally and let the bubbles fall, they pop in beautiful overlapping circles that resemble deep-sea bubbles. Onto the dried backgrounds, have students assemble the make-believe fish. Cut or tear any fishy shape from any color of construction paper and glue it to the paper. Then, depending on the desired effect, add cut or torn dots and stripes, fins and eyes, noses, clothes, horns and beards. Use bits of foil and shiny wrappers, buttons, sticker stars, fluorescent paper. Show students how to create texture by poking holes through paper or folding it and making small cuts. Fringe the edge of a fin, then bend or curl it to make it three-dimensional. Have them make one big fish or a few little ones. Tell them to try to create something that would impress even Dr. Seuss!

Materials

white paper
all colors construction paper scraps
foil and other sparkly bits
scissors
pencils or sharpened wooden sticks
soap bubbles with blue and green food coloring
 added (optional)

Art Activity

Ms. Teacher's Pool

Display

While the class is making the background bubbles, blow a few extra and let them fall onto white bulletin board paper–enough to cover your board. Cut the top edge in reverse scallops to look like waves and fasten it to the board. Paint some blue construction paper with green waves. When it dries, cut out wavy letters to spell "First Grade Pool" as shown on page 10. Attach them as if they were floating and bobbing atop the water.

Art Concepts and Techniques

Bubble prints Collage
Cutting Folding
Pasting

Related Artists

Wassily Kandinsky and Marc Chagall (for their light, whimsical approach to real and imaginary subject matter)

Ape in a Cape

Illustrated and written by Fritz Eichenberg. Harcourt Brace Jovanovich, 1952.
Caldecott Honor Book, 1953.

Story Summary

This is not a story, but an alphabet book, rather tame by today's standards, but appealing for children who love rhyming and the ridiculous.

Illustrations and Comments

What is best about these pictures is that each tells a story beyond the few rhyming words at the bottom of the page. The bear is in despair because he is being chased by a hive of bees which he has probably disturbed while robbing their honey.

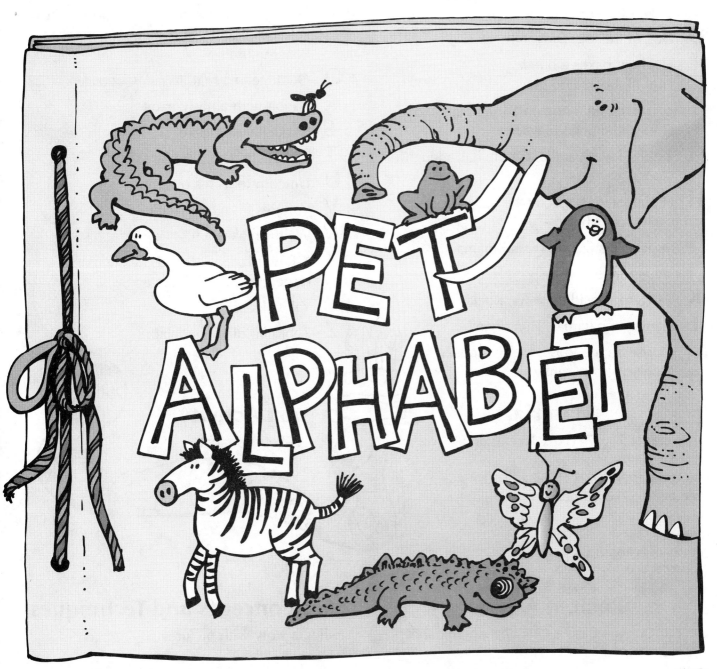

Directions

Read the book and have the children tell what the picture shows that the words don't. Assign each student a letter and help them think of an animal rhyme such as those used in the book (see suggestions below). Illustrate the rhyme using markers or colored pencils on the 7" x 7" (18 x 18 cm) sheet of white paper. On the 7" x 2½" (18 x 6 cm) paper, write the rhyme they have illustrated. Cut out capital letters from scraps of colored paper and glue them in front of the rhyme as shown on page 15. Mount both finished white sheets on colored construction paper, punch holes on the left-hand sides, and string them together to make a class alphabet book.

A Alligator in an elevator,
This ant can't chant, Armadillo

B Butterfly eats a pie, Bullfrog

C Cow, Cat sat in that vat

D Dog in the fog, Dragonfly

E Elephant bakes a bundt,
Emu blubbers boo hoo

F Fish, Frog on a dog on a log in the fog,
Firefly, Flamingo plays bingo

G Gorilla loves vanilla, Giraffe has a laugh,
Goose

H Hippopotamus (got off the bus in front of us), Horse, Hyena

I Insect, This iguana has no mama.

J Jaguar drives a car

K Kangaroos reading news, Koala

L Llamas in pajamas, Lion cryin'

M Moose on the loose, Moth, Mouse,
Monkey gettin' funky

N Newts in boots scoot with loot

O Which Ostrich has the sandwich, Octopus missed the bus.

P Porcupine Valentine, Peacock lost a sock, Platypus, Panda spreading propaganda, Penguin, Puffin

Q Quail getting mail in jail, Quetzal

R Rabbit with a nasty habit

S Snake bakes a cake

T Turkey, Toucan pounds a pan

U Unicorn toots his own horn

V Vultures from many cultures

W Walrus makes a fuss

X X-Ray fish, Linx, Fox, T. Rex demands respect (expect *x* at the end)

Y Yak talks back

Z Zebra holding candelabra

Materials

white paper 7" x 7" (18 x 18 cm) and 7" x 2½" (18 x 6 cm)
colored paper 9" x 12" (23 x 30 cm)
markers or colored pencils
scissors
glue
scraps of colored paper

Art Activity

A Pet Alphabet

Related Artists

Look at Graeme Base's *Animalia*, an alphabet picture book.

Art Concepts and Techniques

Telling a story with pictures

14

Display

Make front and back covers from a bright color of slightly stiffer paper (such as poster board) measuring 10" x 13" (25 x 33 cm). Have each student draw a tiny version of their animal, cut it out and glue it to the cover. Cut letters to spell "Pet Alphabet" from bright, contrasting construction paper and glue those into place. If they do not show up properly, use a black marker to write the letter inside the letter like Eichenberg does in the book. Laminate the cover (and pages) before fastening it to the rest of the pages.

Umbrella

Illustrated and written by Taro Yashima. Viking, 1958. Caldecott Honor Book, 1959.

Story Summary

For her birthday, Momo has received new red boots and a blue umbrella. She is anxious to try them out, but it seems forever until the day comes when it finally rains. As she walks along, the rain makes wonderful music she has never heard before as it hits her new umbrella that she grasps tightly in both hands. When she returns home, she realizes that this is the first time she has not held the hand of one or the other of her parents–she's growing up!

Illustrations and Comments

The combinations of techniques used by the artist to create the illustrations in this book produce an effect that is scrubby and solid and satisfying. Areas of blue and red are laid in to create purples while areas of black are scratched away to create rain.

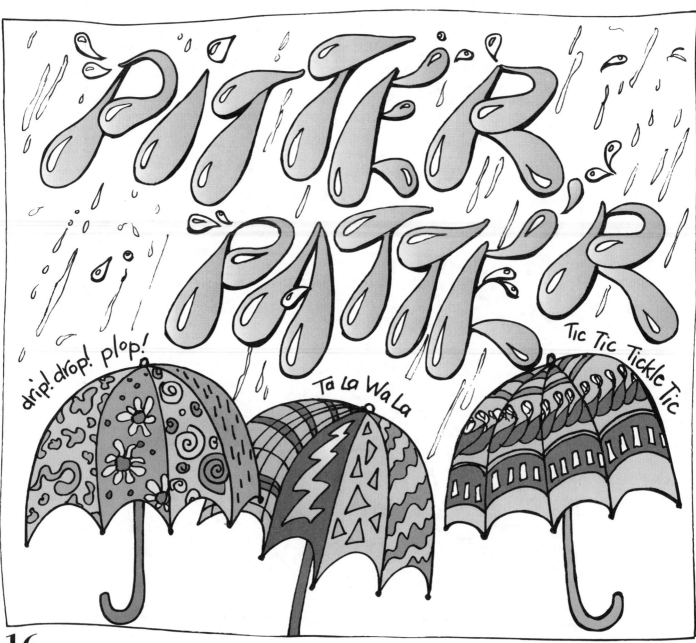

Directions

Read through the story, paying special attention to the passages which describe the sound of the rain in the umbrella. Ask the children what it sounds like to them when the rain hits their umbrella or the roof of their house or car. Have them make up rhythms similar to the ones in the story. Now demonstrate how you can show this rhythm visually by making vertical and diagonal dashes with a little blue water- color onto a sheet of white or pale gray paper. The feeling of dripping rain can also be created by dripping the paint and tilting the paper, or by gently tapping the brush against the opposite hand so the paint shows a direction when it hits the paper. The children need to experiment freely to see what the watercolor can do on their white, blue or gray paper. Spread lots of newspapers or take the classroom outside to create rain pictures. When they have dried, have students write out their rain rhythms in small letters onto their rainy backdrop. Give each student a sheet of bright-colored construction paper and ask them to use the entire sheet to draw an umbrella that they would like to receive for their birthday. They should decorate these with dots, stripes, squiggles and worms in all sorts of bright colors and then cut them out. Cut a long strip of black construction paper and staple to the umbrella as a handle.

Materials

white, pale blue or gray paper
watercolors (blue only)
construction paper in bright colors
crayons or oil pastels
scissors
black construction paper for umbrella handles

Art Activity

Rhythm of the Rain

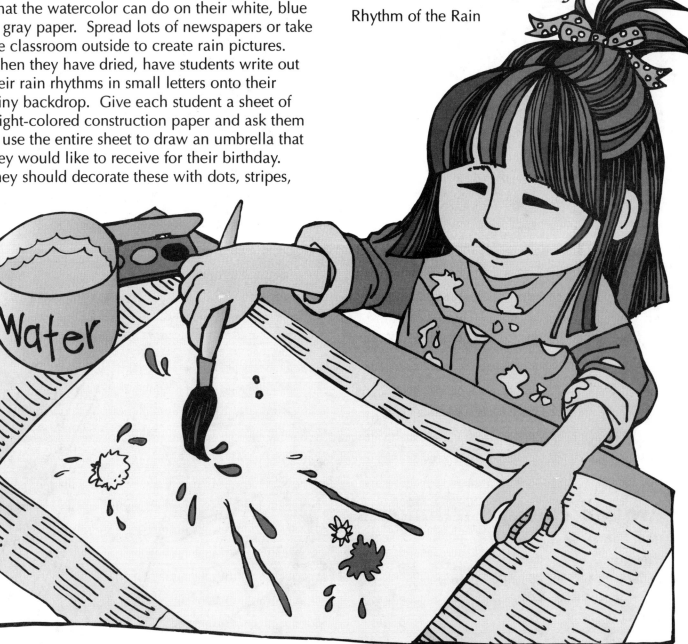

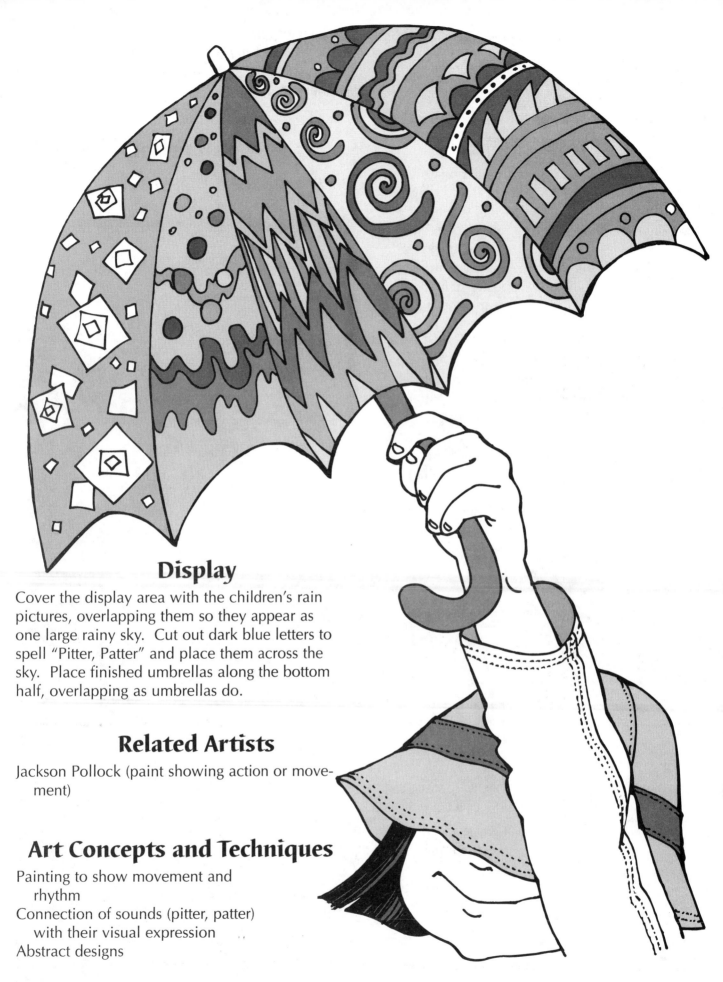

Display

Cover the display area with the children's rain pictures, overlapping them so they appear as one large rainy sky. Cut out dark blue letters to spell "Pitter, Patter" and place them across the sky. Place finished umbrellas along the bottom half, overlapping as umbrellas do.

Related Artists

Jackson Pollock (paint showing action or movement)

Art Concepts and Techniques

Painting to show movement and rhythm
Connection of sounds (pitter, patter) with their visual expression
Abstract designs

18

The Snowy Day

Illustrated and written by Ezra Jack Keats. Viking, 1962. Caldecott, 1963.

Story Summary

Peter wakes up one morning to a snow-covered world. He enjoys the snow in a number of ways throughout the day, exploring the snow and his own normal vivid imagination, but that night he dreams the snow all melts away. To his delight, he awakens the next morning to find the snow is still there and even more is falling. This day, he shares the fun with a friend.

Illustrations and Comments

Keats is famous for his "collage" illustrations. He cuts shapes from paper, printed paper or fabrics and glues them to the paper to create his simple, bold and striking pictures.

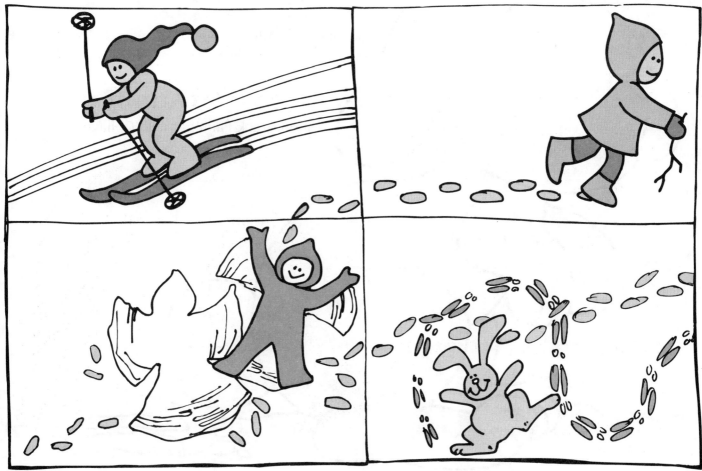

Directions

After sharing this story with the class, have the students look closely at the tracks Peter has made in the snow. Have someone demonstrate how the steps and the angel were made. Using a small sponge dipped into light blue tempera that has been poured in a thin layer into the pie pan, show how such tracks and shapes can be made on snowy white paper. Make some animal tracks, bird tracks, tire tracks, ski tracks and see if the class can guess what they are. Now have each child try out the sponge printing technique by creating tracks on large white sheets of paper. Four students can work from each paint tray.

When the snow track paintings have dried, go back to the book and ask students how they think Keats made the pictures (by using cutout shapes and glue). Point out the patterns in Peter's pajamas and elsewhere. Introduce the word *collage* and explain how it is used by Keats to create the pictures for this book. Now have them try the collage technique by cutting out simple shapes for coats, boots and mittens, animals or cars, from the paper and wallpaper scraps and assemble them on their snow track paintings to show themselves and the animals, skiers or snowmobiles that made other tracks they painted. When the students are satisfied with their collages, they can glue them down and add details with crayons or markers.

Materials

large white paper
small sponges (torn, not cut)
light blue tempera
pie pans or Styrofoam™ trays
book that identifies animal tracks (optional)
paper
wallpaper and magazine scraps
scissors
glue or paste
 crayons or markers

Art Activity

Snow Track Paintings with Collage Kids

20

Display

Cover top 12" (30 cm) of display area with pale blue or gray paper onto which you have painted white spots to represent snow. Cut out bright paper or wallpaper letters to spell the title "The Snowy Day" and glue them across the snowy sky. Hang the students' snow pictures edge to edge to cover the rest of the mural.

Related Artists

Pablo Picasso
Henri Matisse
Kurt Schwitters
Eric Carle
Huy Voun Le
 (wrote and illustrated *At the Beach*)

Art Concepts and Techniques

Shapes
Patterns
Collage
Sponge printing
Assembling
Drawing

Where the Wild Things Are

Illustrated and written by Maurice Sendak. HarperCollins, 1963. Caldecott, 1964.

Story Summary

Max makes so much mischief that he is sent to bed without his dinner, but that night his room changes to a jungle and he becomes the king of the wild things. They spend three pages raising a rumpus until Max smells food and becomes lonely for home.

Illustrations and Comments

Though this book was criticized when it was first published for being too scary for little kids, it has become one the the most popular and well-loved picture books of all time. Sendak's monsters are scary and loveable and wonderful.

Directions

After sharing the story with the class, have them go back through the book and see how many moons they can find in the illustrations. Look especially at the moon on the first wordless page of the rumpus, and note how the light seems to shine around it. Show the students how to achieve this effect by coloring a white or yellow chalk moon shape on the dark construction paper, then smearing it with the fingers. Repeat the procedure with tiny stars. Once the night sky is complete, use colored chalk or pastels to add the monster. The mouth is as good a place to start as any–make a lopsided circle, add sharp teeth, a little blood (most children love blood), then go on to the yellow eyes. Complete the monster with shaggy multicolored fur, horns and a claw or two. Stress that no two wild things look alike, and students should try to make the wildest "thing" possible.

Materials

dark blue, black or purple construction paper
pastels or colored chalk

Art Activity

Wild Things and Moons in Chalk

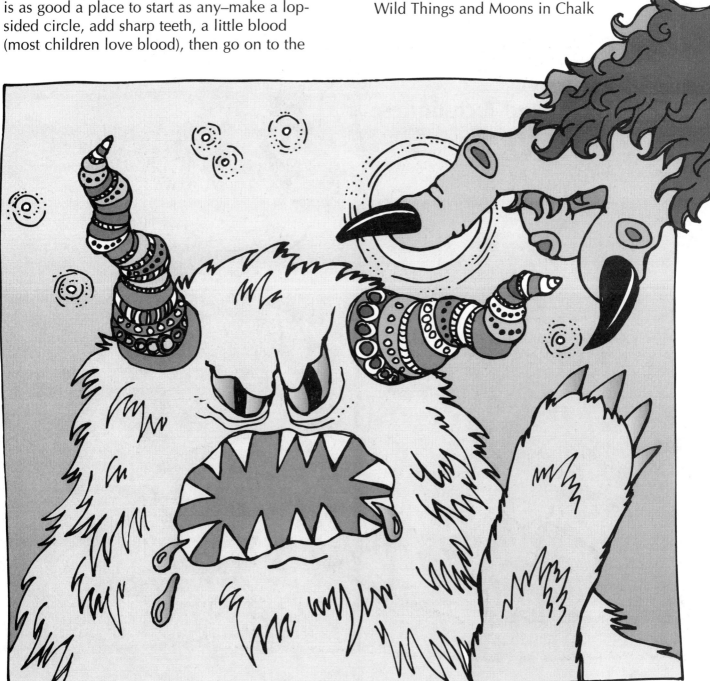

Display

Use a larger piece of dark construction paper and pastels to write "WILD THINGS" in fanciful letters as shown on page 22 and hang the title in the middle of your wild rumpus.

Related Artists

Vincent Van Gogh's moon in *Starry Night*
Edgar Degas' blended pastels
Claude Monet's color combinations

Art Concepts and Techniques

Location of facial features
Drawing from the imagination
Pastels blending

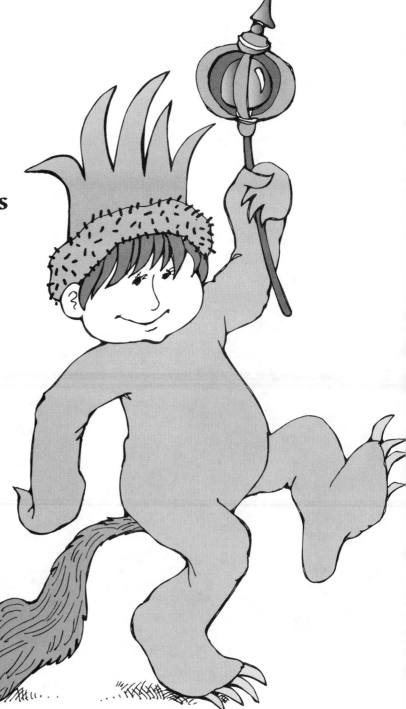

Swimmy

Illustrated and written by Leo Lionni. Pantheon Books, 1963. Caldecott Honor Book, 1964.

Story Summary

Swimmy is a tiny little black fish who swims happily in the sea with his many red brothers and sisters until a big tuna comes and eats them all up–except Swimmy. He swims around sad and lonely for a while but is soon cheered by all the beautiful and wonderful creatures who live around him. He finally meets some more of his own kind, but they will not leave the protection of their rock because they fear they will be eaten. Swimmy has an idea. He has them all swim together in the formation of one giant fish while he takes the position of the eye. Together, they see the world safely and even frighten the other big fish away!

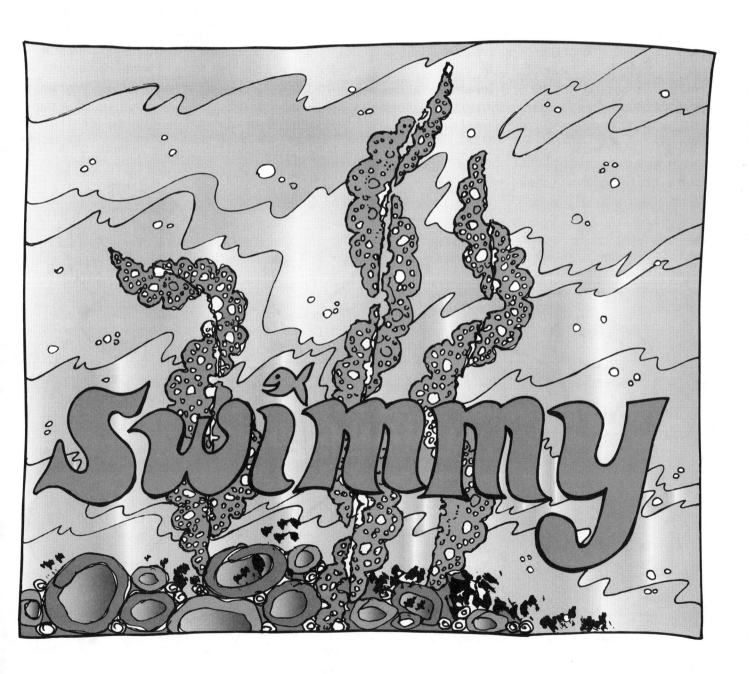

Illustrations and Comments

Lionni has created a wonderful, textural, underwater world in this survival story. These illustrations provide a great opportunity to discuss the vast variety of printmaking techniques.

Directions

When the book has been read and enjoyed, go back through the story paying special attention to all the creatures Swimmy encounters in his underwater world. Discuss how the artist could have made these pictures. He probably experimented with various printing techniques and kept what he thought looked great! Demonstrate some of these techniques as you discuss them from the book. Start with the watery background for the underwater scene by using large brushes to apply a thin watery layer of light blue, purple and green tempera onto a large slick surface such as the stainless steel next to the sink or a large sheet of plastic or acetate. Don't mix the colors completely and laying white paper over it, gently smooth the entire surface to spread the paint. While the students' backgrounds are drying, show them how to cut a fish or other underwater shapes from Styrofoam™ and use a pencil or wooden stick to add eyes, scales and other details. Apply paint generously with brushes to completely cover the Styrofoam™ shapes and print them onto the watery backgrounds. Don't stick to one color. Lionni blends several colors together or painted stripes and dots for much more interesting results. Older students may wish to paint and print strips of doilies for seaweeds, varying the color each time. Print rocks, eyes and other details with bits of sponges, and add dabs and strokes of paint with brushes. Turn mistakes into anenomies or other sea creatures. Stress that this is not a precise art, and some of the best effects are "happy accidents." Finally, cut tiny black "Swimmys" from black construction paper and glue them somewhere onto the art.

Materials

tempera
brayers or brushes
substantial white paper such as finger painting
 paper
Styrofoam™ from recycled meat trays
sponge scraps
doilies

Art Activity

Underwater Wonder World

Display

Make letters to spell the title "Underwater Wonder World" or "Swimmy" using the same techniques as used on the art–cut some letters from Styrofoam™, paint them and print them (they print the reverse), use a portion of a doily for a letter, form some letters with sponges, dab some with brushes and dot the *i* in *Swimmy* with a tiny black construction paper fish. Remember what you told the students, this is not a precise art and some of the best effects are "happy accidents."

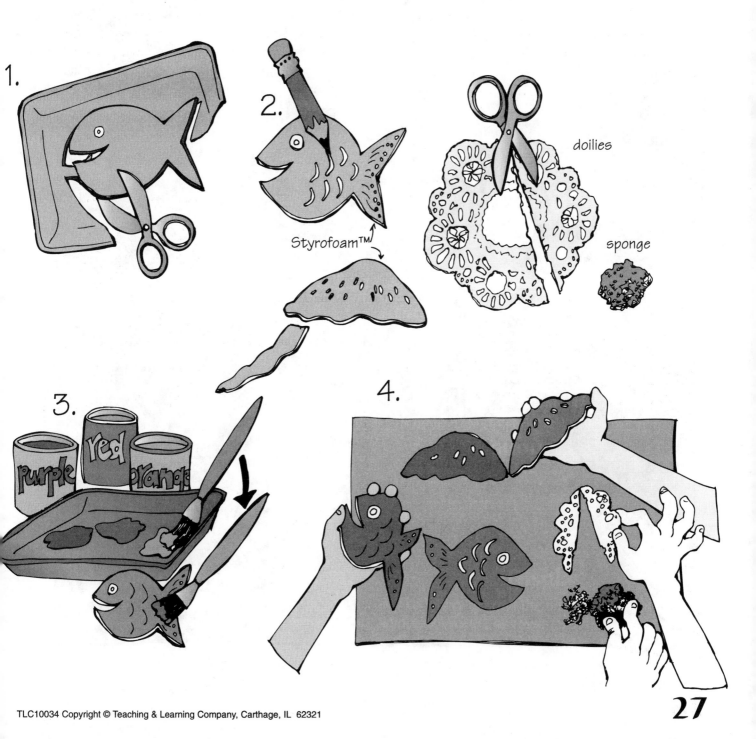

Related Artists

Andy Warhol (for repeating prints)

Art Concepts and Techniques

Printmaking
Painting
Cutting

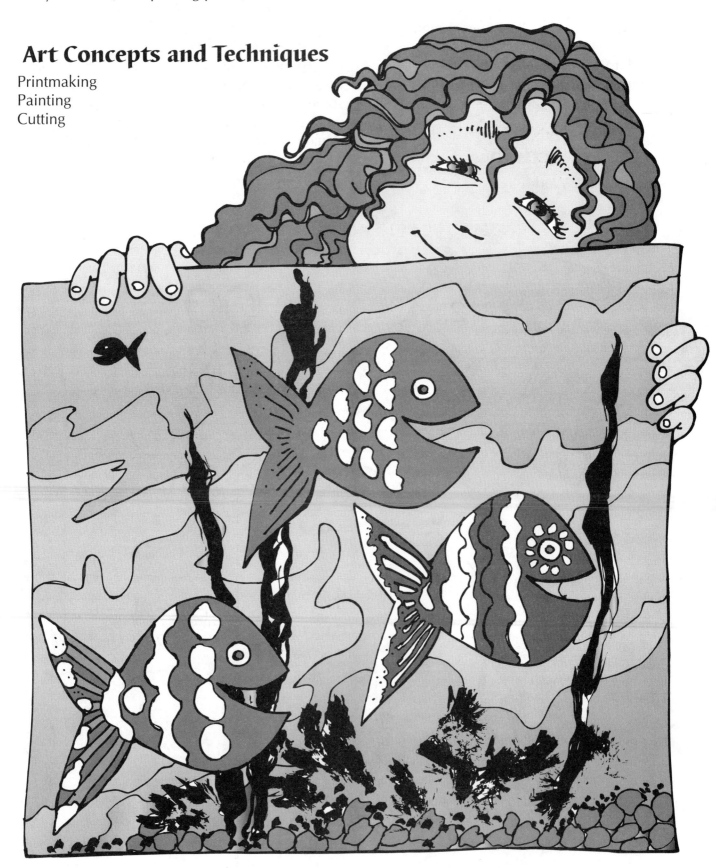

Frederick

Illustrated and written by Leo Lionni. Pantheon, 1967. Caldecott Honor Book, 1968.

Story Summary

Frederick the field mouse and his friends live in a stone wall near the barn. When the weather turns chilly and his friends begin to gather grains, nuts and seeds, Frederick does not help. He says he is gathering rays of sun, colors and words. As the long winter progresses and food supplies are depleted, the field mice are comforted when Frederick, the artist, shares his contributions of warm memories, color and poetry with them.

Illustrations and Comments

Leo Lionni uses collages of simple shapes to illustrate this simple story. When Frederick rekindles the memory of summer, Lionni shows us this concept visually by placing a thought cloud above each mouse that is filled with splashes of color—such a difficult, abstract concept conveyed in such a simple way.

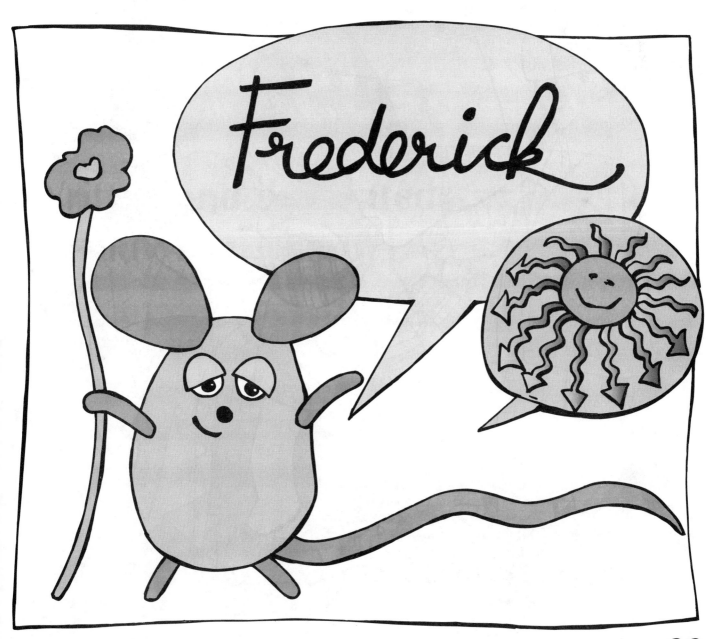

Directions

Once the book has been shared by the class, go back through and note especially the pages where the mice are closing their eyes and imagining the warmth and colors as Frederick describes them. Now have the class close their own eyes as you describe a sunny day, a dip in a cool pool, a bouquet of wildflowers, the delights of a purple Popsicle™ or the soft silky fur of Frederick the field mouse. Have a few students try their descriptive abilities on the rest of the class. Now have the class round the corners of a large sheet of white paper so that it forms an oval shape. Glue or staple a long skinny white triangle to the edge of each oval to finish the "thought cloud." Now have the students close their eyes again and imagine a sensory experience such as those you have already discussed; then color or paint it on their paper cloud without telling their classmates what it is.

Older students may wish to make their own small Frederick by cutting, tearing and gluing construction paper (see illustration on page 29). Then gluing or stapling him to the point of the cloud. If time permits, take turns showing and sharing creations.

Materials

large white paper
black, dark gray and light gray (or brown) construction paper
crayons or paint
glue
scissors

Art Activity

Say It with Pictures!

Display

Cut, tear and glue simple shapes to form a large Frederick (12" x 18" [30 x 46 cm] body) as shown. Attach him to the bottom of the bulletin board or display wall. Cut one more "thought cloud" and inside it write "Say It with Pictures!" or "Frederick, what is he thinking now?" Place this above Fredericks's head along with the students' artwork.

Related Artists

Pablo Picasso (collage)

Art Concepts and Techniques

Collage
Using art to share abstract concepts experienced by the senses

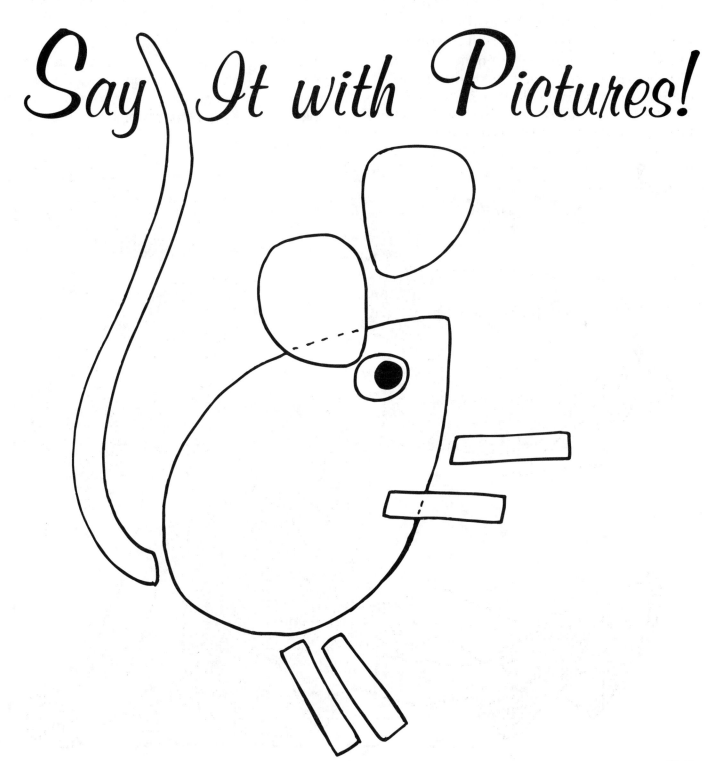

Say It with Pictures!

Sylvester and the Magic Pebble

Illustrated and written by William Steig. Simon & Schuster, 1969. Caldecott, 1970.

Story Summary

Sylvester the donkey finds a fantastic magic pebble that grants wishes. But one day he is so frightened when he encounters a lion on his way home that he wishes himself into a rock. Unfortunately, he cannot change back because he is no longer actually touching the pebble–it lies beside him. Through the summer, autumn and winter he remains a rock while his heartbroken parents search for him in vain. Finally, in the spring, they decide they must go on with their lives and force themselves to go for a picnic. They lay out their sandwiches right on top of the rock, and notice the magic pebble beside it. Sylvester's father picks it up and places it on the rock, and their long lost son appears!

Illustrations and Comments

Steig uses a loose cartoon style to portray these very sad, human-acting characters, which makes the art even more silly and appealing. The two-page seasonal pictures are a highpoint in the book and recall the "Impressionist" painters in subject and style.

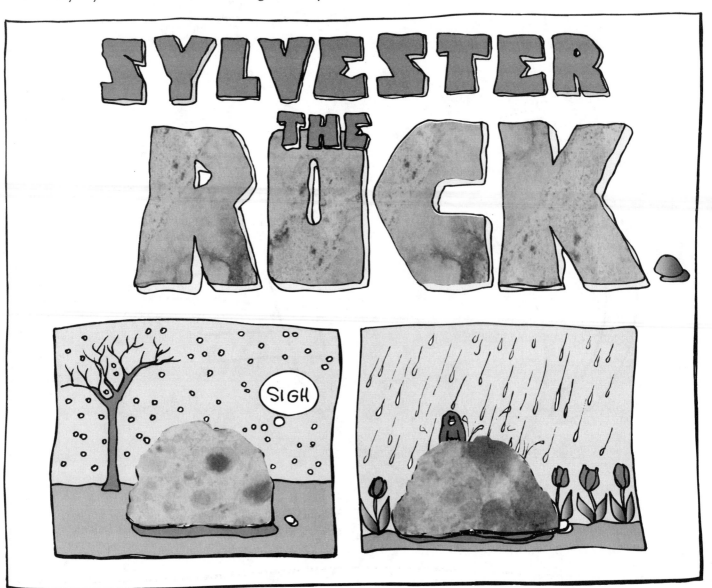

Materials

a tiny quantity of oil paint in stone colors–black,
 browns, grays
turpentine
a few old, cheap brushes
disposable tin roasting pan (larger than 9" x 12"
 [23 x 30 cm])
9" x 12" (23 x 30) white paper
larger white paper
crayons or paints
scissors
red construction paper
baby food jars

Art Activity

Sylvester the Magic Marbleized Paper Rock

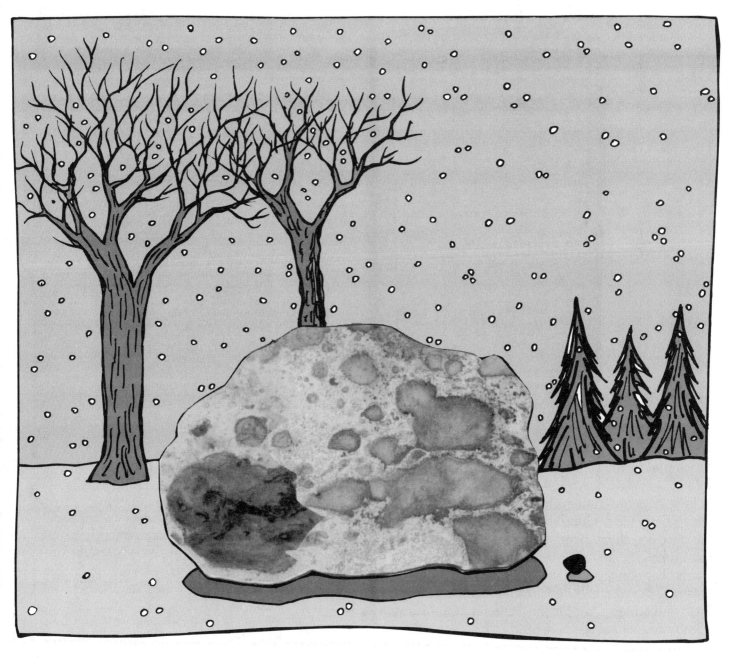

Directions

To make marbleized paper, thin small amounts (1 tsp. or 5 ml) of oil paint with 1 T. (15 ml) turpentine until it is about the consistency of water. Use an old brush and a baby food jar for each color. Fill the foil pan half-full with water (using another container to bring the water to the pan is easier than carrying the pan with water, or do this project at the sink). Have students take turns floating three to four drops of the thinned paints on the surface of the water, stirring gently with the old brush. Then lay their 9" x 12" (23 x 30 cm) paper onto the swirled surface.

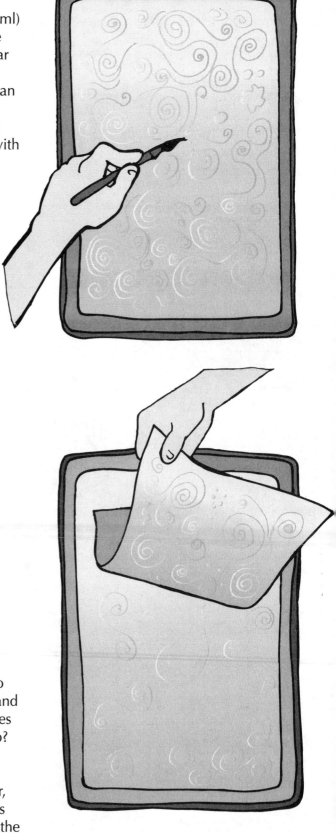

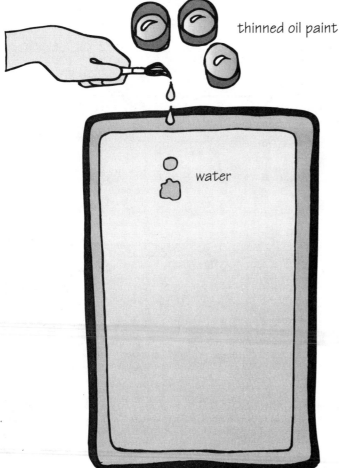

thinned oil paint

water

They should remove the paper immediately and lay it onto nearby newspapers, faceup, to dry. Go back to the story and discuss how long Sylvester was a rock. How many changes took place around him while he just sat there, stone-dumb? Rain, sun, day, night, summer, autumn, winter and spring. Have students cut their marbleized sheets into a big rock shape and glue it onto the center of another sheet of paper, and then color or paint their favorite scene from Sylvester's sad time as a rock. Have them try to be loose and free in the same cartoon style as Steig. Finally, each student should cut a small 1" (2.5 cm) circle from red construction paper to represent the magic pebble and glue it to the picture just near, but not touching the Sylvester rock.

34

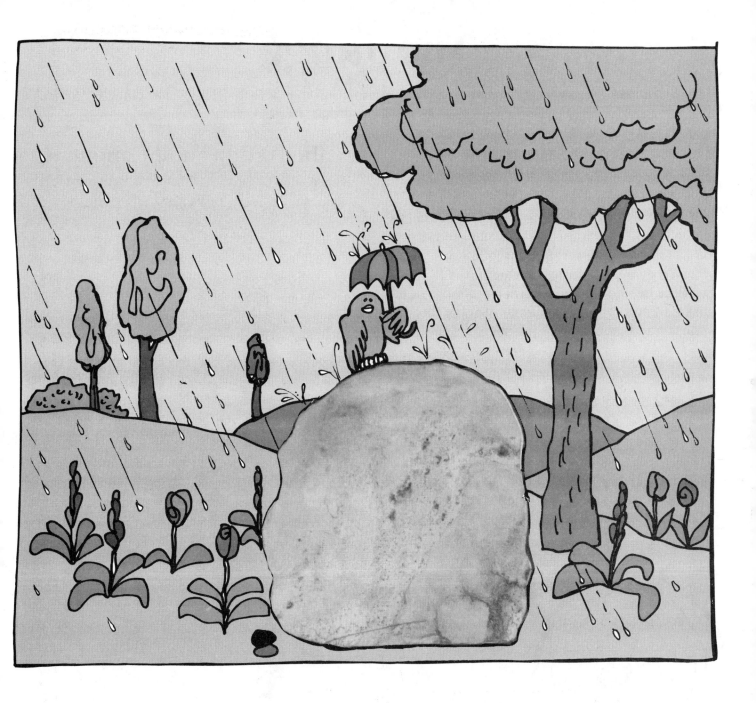

Display

Make a few extra sheets of marbleized paper while you demonstrate the process, and use them to cut out letters for "Sylvester the Rock" or "Sylvester and the Magic Pebble." Glue the "rock" letters to a large sheet of your favorite color paper. Cut a small pebble from red construction paper, and use it for a period at the end. Add a shadow under each letter with a blue, purple or black crayon.

Related Artists

Pablo Picasso and Georges Braque for collage, look for examples of marbleizing

Art Concepts and Techniques

Marbleizing paper
Drawing
Painting
Cutting

The Judge

Illustrated by Margot Zemach and written by Harve Zemach. Farrar, Straus and Giroux, 1969.
Caldecott Honor Book, 1970.

Story Summary

Five prisoners are brought before the judge, one at a time, and each tries to warn him of a "horrible thing" that is coming his way. The pompous judge is sure they must be lying and sends them off to jail for doing so. But as the last prisoner is dragged away, a monster's face appears in the window behind the judge. Then the monster is inside the room, then the judge is inside the monster and then the five prisoners are set free.

Illustrations and Comments

These illustrations are done in a light, cartoon style with all sorts of swirly, curly flourishes.

Materials

brown construction paper
white and black crayons
watercolors
scissors
glue
rulers

Art Activity

Don't Look Now, but . . .

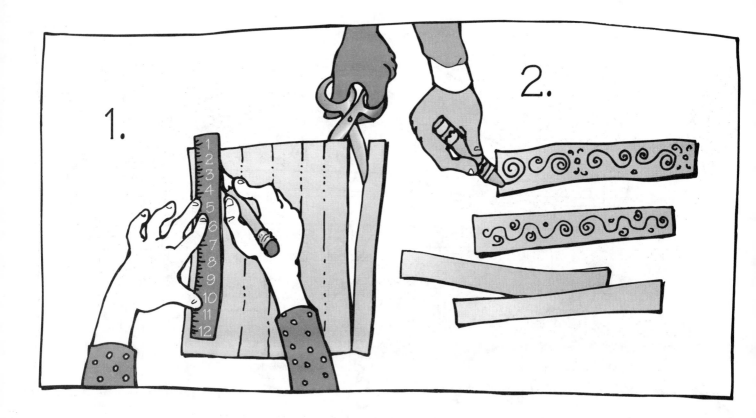

Directions

Enjoy the humor in the story, then take another look at the monster peeking in the window. Explain that this is one artist's concept of a monster, and that with a roomful of artists, there should be many different ideas about this monster's appearance. Have the students close their eyes while you repeat the description of the monster given by the fifth prisoner. When the students have imagined their own monster, have them use a black crayon to sketch it. Once the main lines are completed, use a white crayon, pressing firmly, to add details such as curly fur, dots, stripes or splotches. These will not show up well when drawn but will magically appear during the next step of the process when the pic-

ture is painted with watercolor "washes." Instruct the students that a wash is a technique using a little paint and a lot of water. The wax in the crayons resists the water so the white details magically appear, and the black lines will not bleed. Students needn't be concerned if the colors are not perfectly inside the lines–the art is more spontaneous and interesting if some of the colors blend together. While the "horrible things" are drying, have the students use rulers to draw window frames on the brown construction paper, as shown, in thin individual strips to form the individual panes. These should be glued in place around each child's monster, the excess brown trimmed away, then decorated in rococo swirls with black crayons.

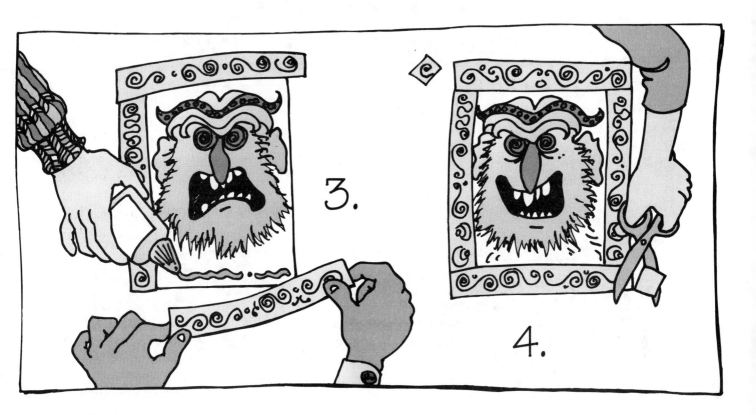

Display

Use a white crayon and press firmly to write "The Judge" or "Don't Look Now, but . . ." on a large sheet of white paper. Have the early finishers paint over the letters with watercolor washes of many colors to make the letters appear. On a large sheet of white butcher paper, trace the head and outstretched arms of a student volunteer. Draw vertical lines down from the arms for the length of the robe. Turn this outline into a judge who has just turned to see a "horrible thing" by adding masses of wild curls with a white crayon and pale gray wash over it. Paint the judge's robe and hands and cut him out. Once the windows are placed in rows with their "things" peeking in, the judge can be attached at the bottom of the display so he appears to be in front of them, frozen with fear. If possible, place him so the bottom of his robe touches the floor of the classroom, and place black shoes peeking out from beneath it. You may want to add a triangular brown transom above the pictures to resemble the courtroom window.

Related Artists

Leonardo da Vinci's and Albrecht Durer's black and white rococo sketches
Martin Schongauer's *Temptation of St. Anthony* has great, horrible "somethings"

Art Concepts and Techniques

Watercolor wash
Wax resist
Imagining appearance from description
Measuring and drawing with rulers
Cutting

Ox-Cart Man

Illustrated by Barbara Cooney and written by Donald Hall. Viking, 1979. Caldecott, 1980.

Story Summary

This early nineteenth century New England farmer and his family have worked all year long to fill the ox-cart for the long journey to Portsmouth to sell it and its contents. Once everything is sold, the farmer buys a little something useful for each family member, a bag of wintergreen peppermint candy for a treat, walks back home and the whole process begins all over again, in the never-ending cycle of the seasons.

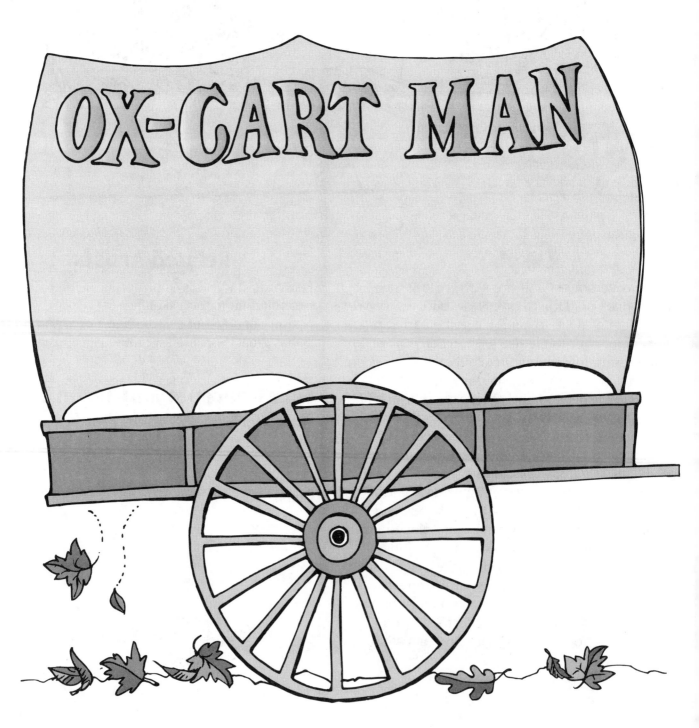

Illustrations and Comments

Barbara Cooney has illustrated this book in the style of the artists, called "limners," who painted what is known as American primitive art in the early nineteenth century. She uses a long, horizontal framework to best reflect the Ox-cart man's journey through the New England landscape.

Directions

Once the students have enjoyed the book, go back over the pages which list the items that fill the ox-cart to be taken to the market in Portsmouth. As each item is mentioned, add it to a list and briefly discuss where it came from. Was it grown? Made? By whom? Students may notice some items in the illustrations which are not mentioned in the text. When the list is complete, have each child choose one of the items to paint or color, paying special attention to add details such as eyes on the lumpy potatoes, red and green areas on the apples, curly leaves on the cabbages, individual straws on the brooms, plaid on the blanket and so forth. Cut out the items when the paint has dried and pile them into the class ox-cart.

Materials

white paper
paint
crayons
scissors
cardboard or oaktag

Art Activity

Fill the Ox-Cart

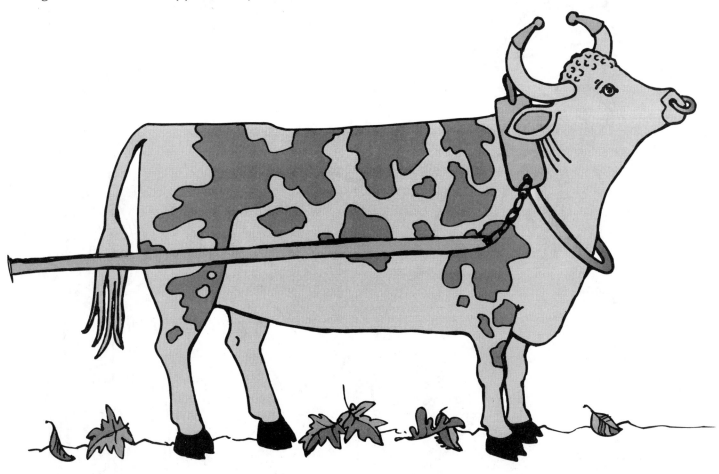

Display

Trace or have a student draw an ox onto large white paper and color or paint the details–pink nose, brown spots, black hooves, yoke and harness. Cut out the animal and attach it to the bulletin board or display area. Behind it, add the ox-cart by using blue construction paper in rectangular shapes. Have children add the grain of the painted wood with a darker blue or purple crayon. Glue additional blue construction paper to a large sheet of oaktag or cardboard,

and draw a wheel for the cart by tracing around a wastebasket or other large round object. Cut it out and attach it to the appropriate spot on the cart with a study tack at the center so that it will turn. Use additional white paper to shape a cover for the cart. Fill the finished cart with the students' artwork. Collect autumn leaves from the ground outside and attach them along the bottom of the bulletin board to form the ground. Save a few to float in the sky around the title "Ox-Cart Man."

42

Related Artists

Linton Park
Edward Hicks
Other early "limners" many of whose names are
 unknown though their work exists

Art Concepts and Techniques

American Primitive style
Attention to details in nature
Drawing
Painting
Cutting

The Garden of Abdul Gasazi

Illustrated and written by Chris Van Allsburg. Houghton Mifflin, 1979. Caldecott Honor Book, 1980.

Story Summary

Little Alan Mitz has been asked to look after Miss Hester's badly behaved dog, Fritz, while she is away for the afternoon. Though he tries his best, he cannot manage to keep Fritz from bolting into the forbidden garden of Abdul Gasazi, retired magician. When he summons the courage to go up to the mansion to ask for the dog back, Gasazi says, "Certainly, only he has been changed into a duck." (The magician does not care for dogs.) He starts for home, carrying the dog/duck, but it flies away on the walk back. Worried about how he will explain the day's events to Miss Hester, he reluctantly climbs the porch steps to find the dog safe and sound. After all, no one can really change dogs into ducks–can they?

Illustrations and Comments

Van Allsburg has used only pencil and drawing paper to render these fine illustrations, which are sophisticated and simple at the same time, appealing to all ages. Each one is a masterful study in black, white and every tone in between. Van Allsburg's precise technique makes the story seem eerier, somehow.

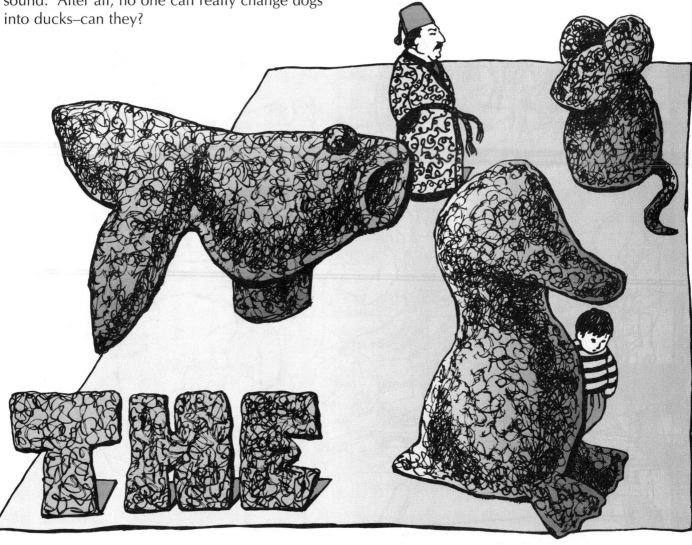

Materials

Celluclay™ or egg carton clay (see recipe on page 2)
cardboard rolls
masking tape
newspapers
yellow and blue tempera
stiff poster board for base or indoor-outdoor carpet scrap
pencils
white paper stiff enough to stand

Art Activity

The Garden

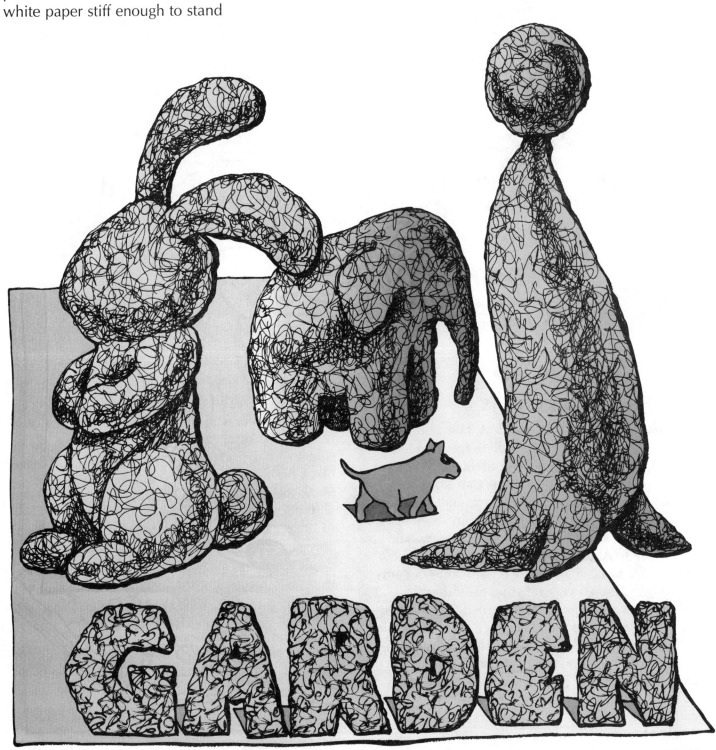

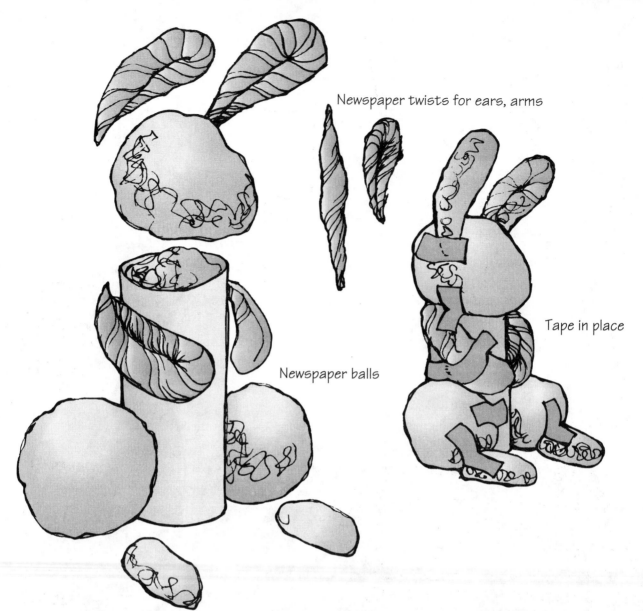

Newspaper twists for ears, arms

Newspaper balls

Tape in place

Directions

After reading the book to the class, take another look at the front cover, and explain the term and process of "topiary." Ask the students if they suppose the author wants us to think that Abdul Gasazi turned real animals who accidentally wandered into his domain into these bushy animals? Have the students think of an animal they would like to see in Abdul's garden, and show them how to form the basic shape. Use an armature of cardboard rolls, stuffed with newspaper, and add appendages and other details formed from twisted and rolled newspaper and attached with strategically placed masking tape (use sparingly). When basic shape is complete, cover it with a layer of clay and pinch and poke to form the finer details. Because the clay is somewhat bumpy, the surface will resemble leafy bushes, but some additional pinching may be required to create more texture.

Allow the "topiary" to dry completely, standing upright, and then paint it, using yellow and blue tempera to mix a variety of shades of green. Older students may even want to add a touch of red, black or white to create even more green shades. Show the students how to cover the animal bushes with color; then dab on the different shades. Arrange the topiary in a "garden" by placing it on a mat of indoor-outdoor carpeting or green paper or poster board. Now have the students use soft-lead pencils to draw small figures of Alan and themselves on stiff white paper in the correct proportion to the bushes. Talk about black, white and all the different shades of gray, using the illustrations in the book as examples. Cut the figures out, leaving extra paper on the bottom to fold up (as shown on page 47) so the figures can stand in the garden. You may wish to add a dog, ducks and even the magician himself.

46

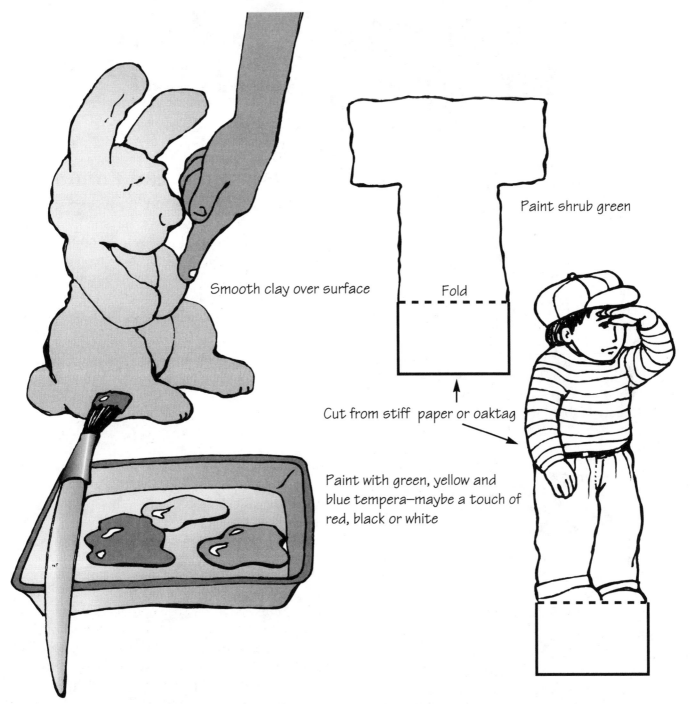

Smooth clay over surface

Paint shrub green

Fold

Cut from stiff paper or oaktag

Paint with green, yellow and blue tempera—maybe a touch of red, black or white

Display

Use more stiff paper and the same method of construction to draw block letters that spell the word *Garden.* Paint them with the same technique as the topiary. Place the figures and letters in the garden.

Art Concepts and Techniques

Three-dimensional sculpture construction
Color mixing
Values and gradation
Figure drawing
Relative size and proportion

Related Artists

Maurits Corneille Escher (pencil renderings)
Henry Moore (bold sculptural forms of topiary)

The Grey Lady and the Strawberry Snatcher

Illustrated and written by Molly Bang. Four Winds Press, 1980. Caldecott Honor Book, 1981.

Story Summary

Because this story has no words at all, the students are required to read the pictures. Fortunately, even nonreaders can do this well. The story is about a lady with grey hair and dress who purchases a box of strawberries and is then stalked on her way home by a strange blue character with red fingertips who wants to snatch them from her. Molly Bang, the author and illustrator, plays visual tricks on us and the snatcher. He loses her (as we do) because she blends into the grey background on which the pictures are drawn. Never mind, he encounters some blackberry bushes which cause him to forget all about the grey lady's strawberries.

Illustrations and Comments

Not only does the artist turn the background into the grey lady and vice versa, but she fills each illustration with visual jokes–mushrooms grow wherever the snatcher steps, the green grocer has a green thumb, an Asian lady in traditional dress and a bucket of eels rolls by on her skateboard, which the Snatcher snatches in his pursuit of the strawberries. Clearly, this story is occurring in a surreal setting. When Molly Bang is not tricking your eyes, she is treating them with rich, intricate visual detail.

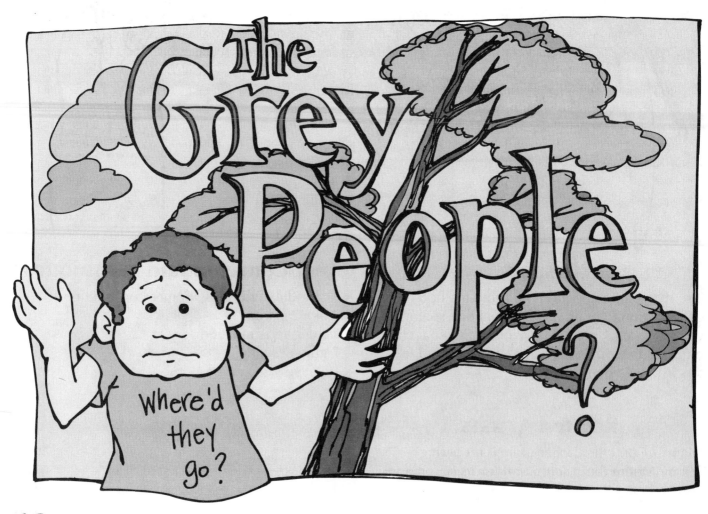

48

Materials

pale grey paper
crayons or paints
imagination

Art Activity

Where'd They Go?

Directions

Having read the pictures to learn the story, look more closely at those which show the grey lady, and ask the students how they can see her when the artist left her hair and dress blank. When the background, or negative space, is filled in around the figure, the eyes see the figure. Older students will see that even when some of the background is grey, we still see the whole figure because of what we know must be there. Go through the illustrations to see how the artist uses this technique on each page. Have the students see if they can complete their own lady or man by painting the face and hands only, then painting the background around where the figure should be. They may need to sketch the outline of the figure very lightly with pencil first or lay a "lady" shape cut from heavy paper. Draw or paint over the shape, remove the shape to expose the blank "lady" underneath, then add the face and hands. It is a challenging exercise to paint backwards!

Display

On another, longer sheet of paper, lightly pencil in the letters to spell "Where'd They Go?" or "The Grey People," and then paint the background only so that the letters can be seen in the same way that the students' figures can. Try to include a tree or object which is the color of the background as the book does. Place the title sheet on a blank bulletin board, and don't add the students' work. Where'd it go? It has been hung in various spots around the room.

Related Artists

Henri Matisse
Salvador Dali (surreal subject matter)

Art Concepts and Techniques

Negative space
Drawing
Painting

A Chair for My Mother

Illustrated and written by Vera B. Williams. Morrow, 1982. Caldecott Honor Book, 1983.

Story Summary

The other house had been burned in a fire, and though no one was hurt, the little girl, her mother and her grandma lost all their belongings. They were saving all the tips Mama earned at the Blue Tile Cafe and any other extra pennies to buy a big, soft, flowered chair so Mama could relieve her tired feet when she got home at night. Finally the jar is full and they find just the right chair, haul it home and snuggle happily into it.

Illustrations and Comments

The illustrations in this book are not polished and sophisticated–they are simple, primitive and charming because of it. The borders around each page are painted in a bright contrasting color and repeat a motif that appears in the picture to add a nice finishing touch.

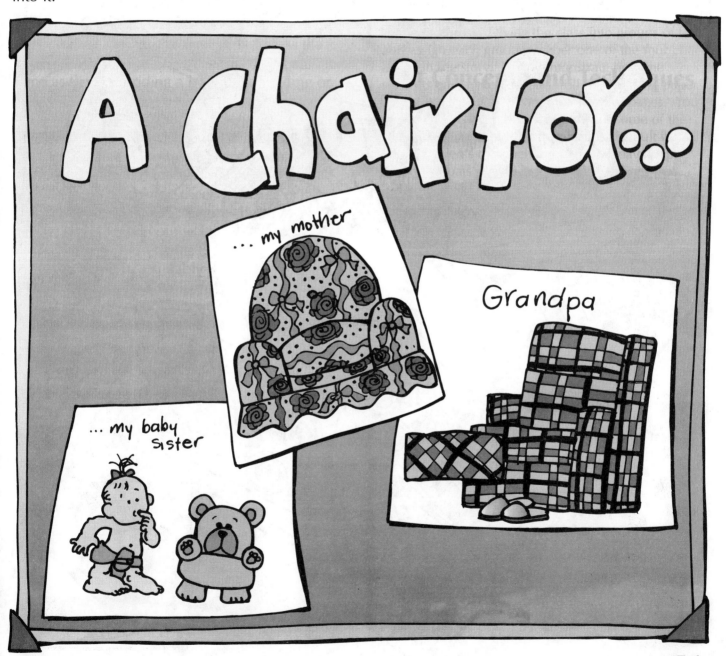

Directions

Having enjoyed the story as a class, go back and look at the chairs. Ask the students to explain why they think the chair that was chosen was just the right chair for the family in the story. Have them close their eyes and imagine what kind of chair would be best suited for their mama, dad, grandpa or someone else they love. Talk about the pattern on the chair and other possibilities–stripes, plaids, dots, paisleys, swirls, etc. Have each student color or paint on a sheet of white paper, a pattern they think would suit a favorite person of theirs. Cover the whole sheet as if it were a piece of fabric. When this painting is dry, have each student choose a sheet of construction paper for a background in the color that will make their pattern show up best. Complimentary colors are those that are opposite each other on the color wheel, such as red and green, blue and orange or purple and yellow. These combinations, when put together, make each other look brighter. Have students cut cushions and chair shapes from their painted pattern sheet, and arrange them on the contrasting construction paper to form the perfect chair for their favorite person, as shown. Once the main pieces have been glued down, the student may wish to add details, or even a colored and cut out person enjoying their chair, with their name written above it. Thin white strips of paper and colored triangles can be added around the edges of the art to simulate photos which have been placed in an album.

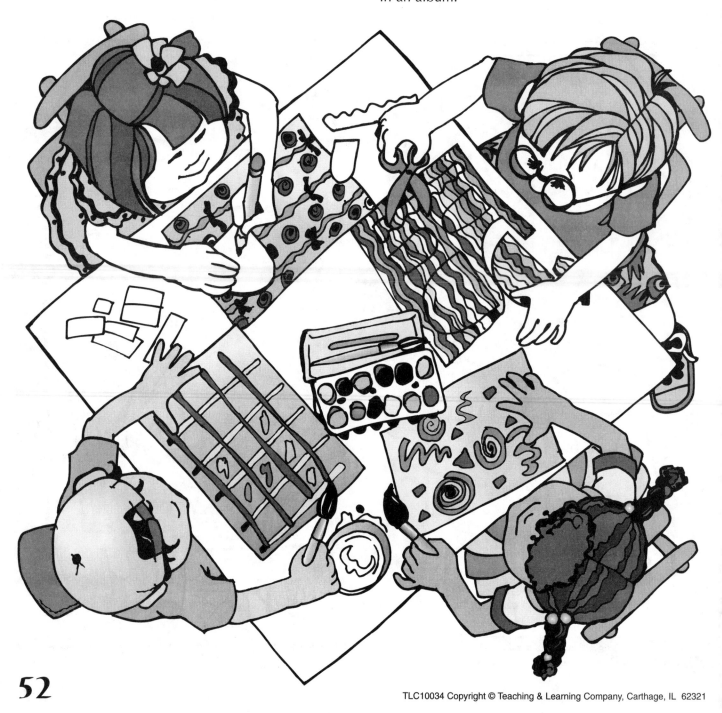

52

My Mother's Chair Patterns

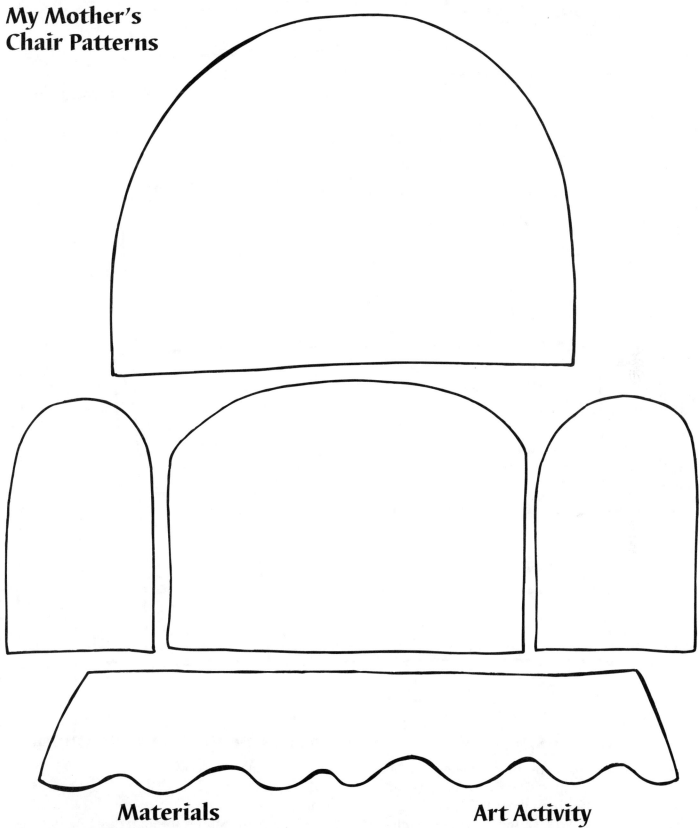

Materials

construction paper in bright colors
white drawing paper
watercolors, tempera, crayons or Craypas™
scissors
glue

Art Activity

A Chair for . . .

Related Artists

Henri Rousseau
Diego Rivera

Grandpa's Chair Patterns

Footrest goes here

Display

Use watercolors to paint several sheets of white paper in various festive colors. When sheets have dried, cut out from them the title letters "A Chair for . . ." and attach them to the bulletin board. Then place the artwork of the students below them so that each picture finishes the sentence. Attach artwork to a black background so that the display appears to be a page from a scrapbook.

Art Concepts and Techniques

Complimentary colors
Patterns
Collage
Showing personalities through design and color
Coloring or painting
Cutting
Gluing

54

Hey, Al

Illustrated by Richard Egielski and written by Arthur Yorinks. Farrar, Straus and Giroux, 1986.

Story Summary

Al and his little dog Eddie live in a small room in a large city, but Eddie is not satisfied with their existence–he wants more. One day a large bird comes to the window and invites them to go to a special place, and Eddie insists that they go. They arrive at a bird paradise island in the sky and cannot believe their good fortune until they notice to their horror, they are beginning to turn into birds. They frantically fly away for home. Al barely makes it back to his room. Eddie plunges into the sea, but survives somehow and when he appears at Al's door, they both appreciate their old way of life together much more than before.

Illustrations and Comments

In this cross between *Pinocchio* and *The Wizard of Oz*, Egielski appeals to our sense of the bizarre and a little bit frightening. He also uses color and size effectively as he proceeds from Al's drab, confined box of a room to the two-page spreads of Bird Paradise. In the end, the art, seems to find the same happy medium as does Al: he is back in the safety of his small room, but he is brightening it up.

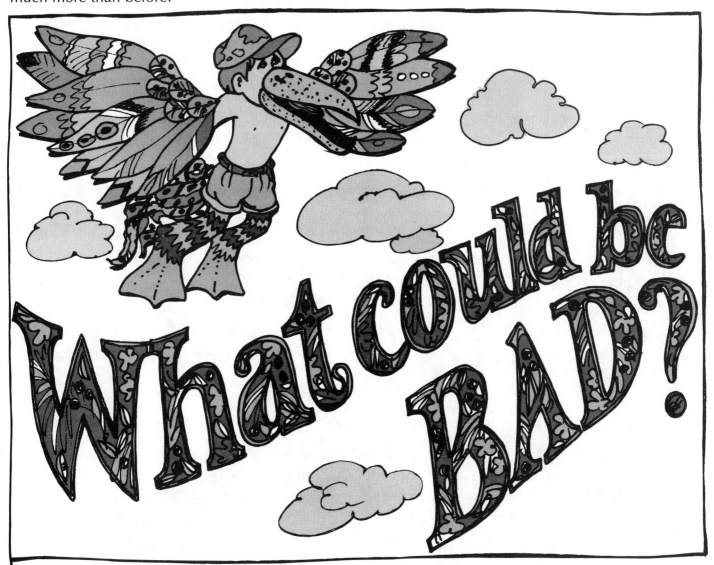

Directions

Once the class has enjoyed the story, look back to the page where Al and Eddie are hanging on the tree and being greeted by all the birds on the island. (Note the Dodo on the far left; he still has one human arm.) Ask the students how many of the birds they recognize as actual species and which ones they think the artist has created just for the book. Point out the beautiful colors and different shapes and sizes. Now turn the page and look at the transformation of Al and Eddie. Like Pinocchio, they are changing and, of course, it couldn't really happen. But if it could, what kind of bird would the students turn Al into? Real or imaginary? What colors of feathers and beak? Copy enough patterns of Al (the man) for each student and one to demonstrate how to transform him into a bird. Glue bright-colored feathers, torn or cut and scored, along the arms in an overlapping fashion to show emerging wings. Cut a beak or bill, webbed or clawed feet and glue them over the human feet. Use crayons to add additional details as desired, but have the students leave something human to indicate a transformation in progress. Cut out the creations and have the students give them a bird name with the word *Al* in it such as, PALican, ALstrich, ALmorant, StorkAL.

Materials

white paper with *Al* traced or copied onto it
crayons or oil pastels
brightly colored scrap paper
scissors
glue

Art Activity

Bird Paradise?

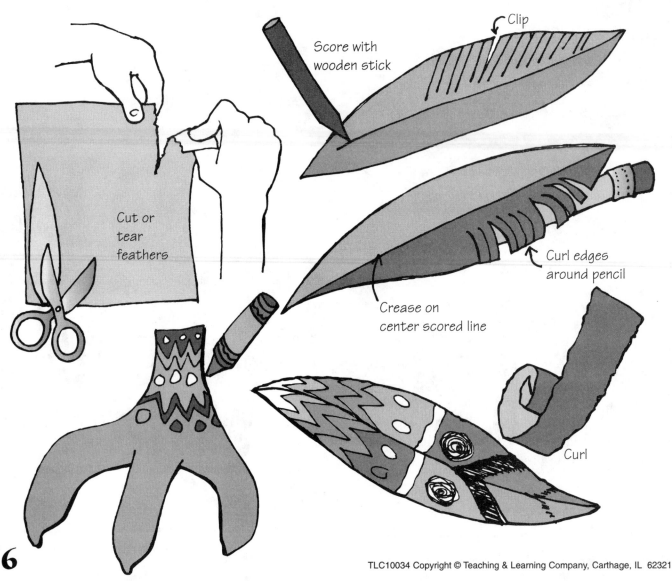

Cut or tear feathers

Score with wooden stick

Clip

Crease on center scored line

Curl edges around pencil

Curl

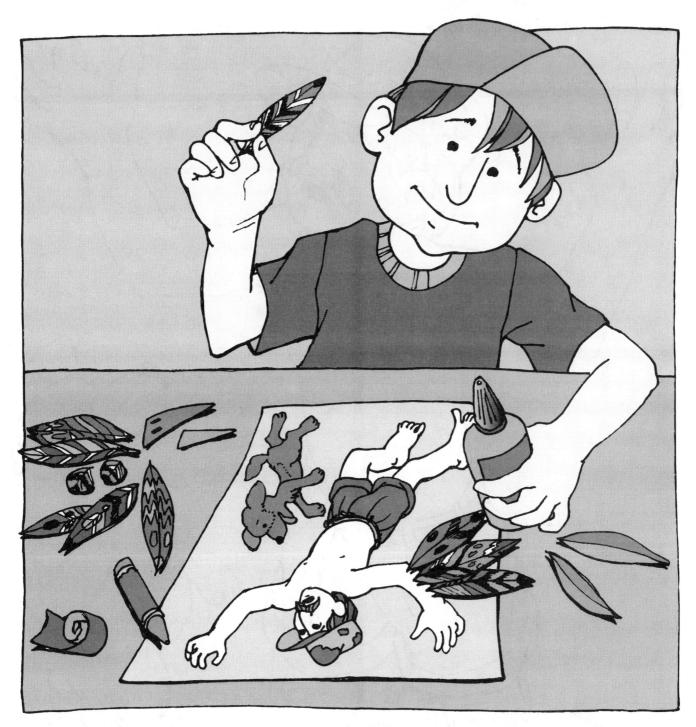

Display

Cover the display area with pale blue or aqua paper. Use wisps of cotton, scraps of paper or white spray paint to add a few clouds. Cut out the letters to spell "Bird Paradise" or "What could be BAD?" using scraps of cloth, wrapping paper or wallpaper with bright, tropical prints. Place letters along the bottom of the display and the "bird-people" flying above them.

Related Artists

Salvador Dali, illustrator Miss Moffit's cut-paper pictures

Art Concepts and Techniques

Creating texture by tearing and scoring paper
Surrealism
Drawing
Gluing
Cutting

58

Owl Moon

Illustrated by John Schoenherr and written by Jane Yolen. Philomel, 1987. Caldecott, 1988.

Story Summary

Owl Moon tells of a wintry night when a small child goes "owling" with her father for the first time. As they walk silently on, her father occasionally calls out, "Whoo–whoo–who–who–who–whooooo!" with no reply, only the dark shadows behind the pines. When you go owling, you have to be brave. Suddenly the call is answered. A huge shadow becomes an owl that her father captures in his flashlight for a frozen moment in time.

Illustrations and Comments

The artist, John Schoenherr, a gifted watercolorist, was moved to illustrate this gentle story because of the fond memories he had of going owling. As the children enjoy the story, point out the many shadows and footprints in the pictures. Have them search for the animals on each page.

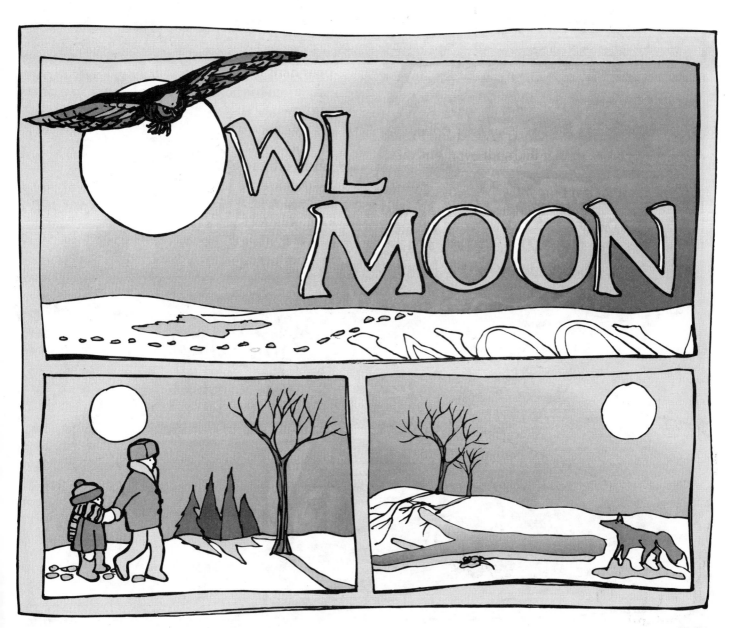

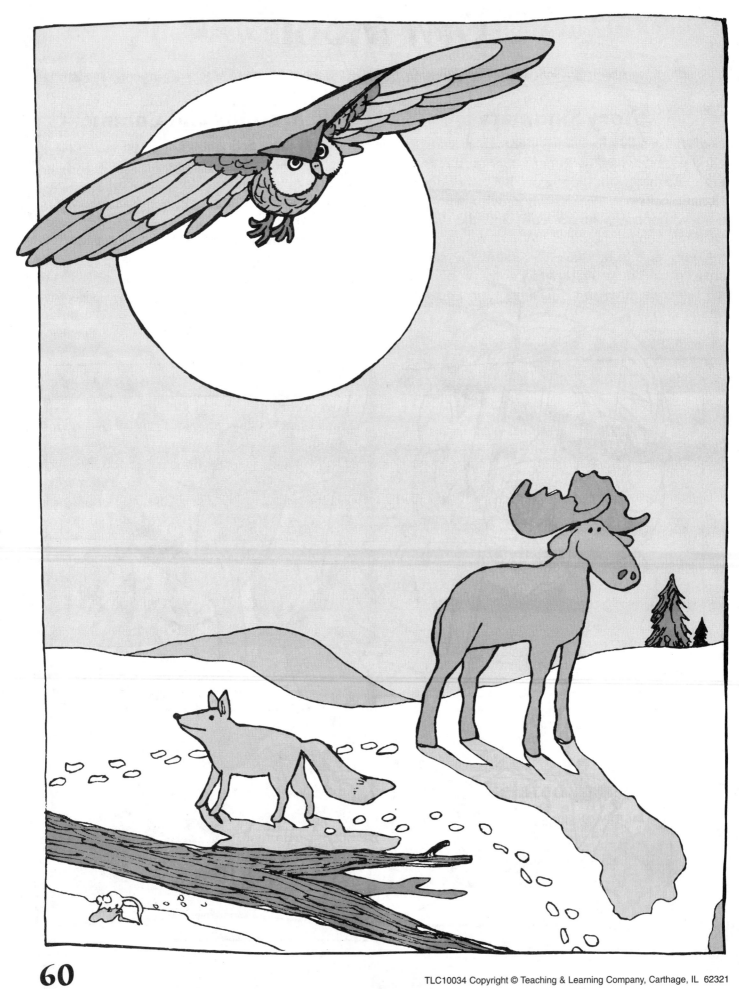

Add shadows cast by the trees, animals and people with a blue crayon.

Materials

wallpaper samples with satin-sheen (for moon)
12" x 18" (30 x 46 cm) black or dark blue construction paper
6" x 18" (15 x 46 cm) and 6" x 6" (15 x 15 cm) white construction paper
scissors
glue
crayons

Art Activity

Moonlit Night with Creatures and Snow Shadows

Display

Cut out a wallpaper circle for the *o* and glue it to a large sheet of dark construction paper. Use crayons or oil pastels to draw the remaining letters to complete the title "Owl Moon," and add a highlight of white on each letter where the moon shines on it. Add snow across the bottom of the page with white construction paper, and draw shadows in blue crayon. Have an early finisher draw an extra owl flying and glue it to the sky. Don't forget to draw the owl shadow under it on the snow. Place student artwork around title art.

Related Artists

Winslow Homer
Andrew Wyeth (worked in similar styles to illustrator John Schoenherr)

Art Concepts and Techniques

Shadows and highlights
Shapes
Tracing
Cutting
Gluing
Drawing

Directions

Cut the 6" x 18" (15 x 46 cm) white paper lengthwise in waves or bumps and glue it onto the bottom of the dark paper to create the snowy ground. Trace (or teacher pretraces) a 4" (10 cm) or 5" (13 cm) circle on the wallpaper with a plastic lid to represent the moon. Cut it out and glue it in the sky. Using the 6" x 6" (15 x 15 cm) white scraps, draw, color and cut out small pictures of themselves, dressed for owling, or any of the animals they have spotted in the book. Students may include others they may meet while owling. Glue each creation somewhere on the picture. Use crayons or oil pastels to draw dark brown winter trees and pointed green pines directly onto the picture; then outline each tree with white along the side which faces the moon, to create the effect of the light from the moon. Finish the picture by adding footprints to each creature.

Song and Dance Man

Illustrated by Stephen Gammell and written by Karen Ackerman. Alfred A. Knopf, 1988. Caldecott, 1989.

Story Summary

When his three grandchildren come to visit, Grandpa, former vaudevillian song and dance man, takes them to the attic, opens his dusty trunk of memories and performs his old act: cracking jokes, playing "Yankee Doodle Boy" on the banjo and, best of all, tap dancing. Though he sometimes misses the "good old days," he wouldn't trade a million of them for the time he spends with his wonderful grandchildren.

Illustrations and Comments

Stephen Gammell uses pencil and colored pencils in a loose, scribbly style to create a great deal of excitement and movement in these illustrations. If ever pictures could actually perform the old soft shoe, these pictures do.

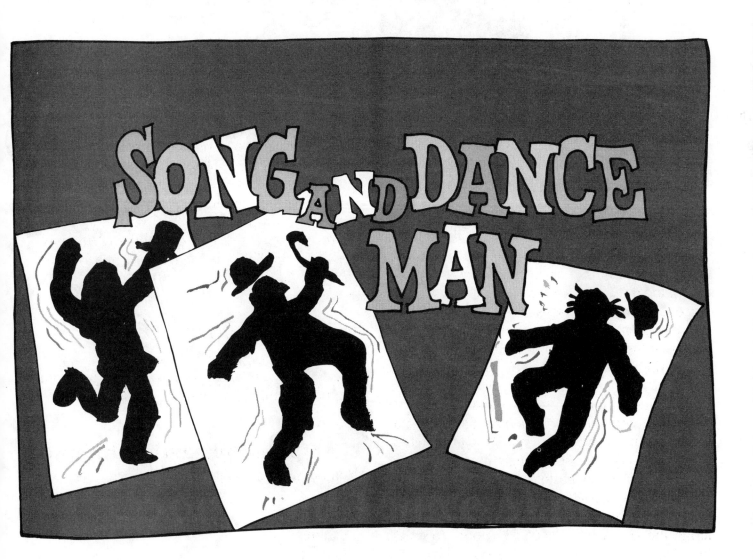

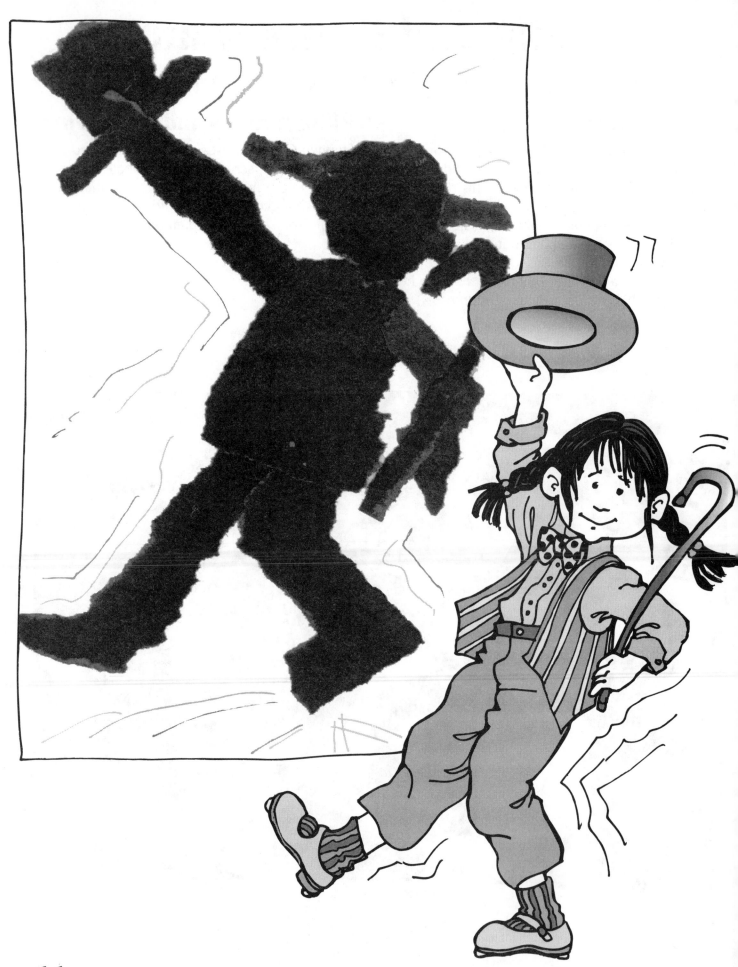

Directions

Once you have shared the story with the class, go back through the book for another look at the pictures. Pay special attention to the way the artist shows the movement of Grandpa dancing: the lines here and there around the dancing figure, the faint extra foot and cane to show where those objects were a second before and the multicolored rays that streak this way and that about Grandpa, like so many spotlights. Point out that though the picture doesn't actually move, it does seem to. Have the students tear scraps of black construction paper to make a head, body, arms, upper and lower legs, maybe even a hat and cane, and then arrange and rearrange them onto their "stage" of white paper. This should be free, loose and fun as the students make their scraps dance. When they achieve an arrangement they are happy with, they should glue the pieces down. Then using crayons, markers or colored pencils, draw lines of movement around their figures just as Stephen Gammell did in the book.

Materials

large white drawing paper
black construction paper
glue
crayons, markers or colored pencils

Art Activity

Silhouettes Soft Shoe

Display

Cut letters for the title "Song and Dance Man" from all bright colors of construction paper and arrange them across a display area with a black background as if they are themselves dancing the old soft shoe! Surround the letters with the students' dancing characters.

Related Artists

Marcel Duchamp
Jackson Pollock and Morris Louis (their work is record of the movement of paint as it was applied to the canvas by unconventional means)

Art Concepts and Techniques

Movement expressed with line
Movement of a figure
Gestures

Color Zoo

Illustrated and written by Lois Ehlert. Lippincott, 1989. Caldecott Honor Book, 1990.

Story Summary

The zoo is filled with animals of every shape, size and color and so is this clever cutout book by Lois Ehlert. It begins with a short poem about zoos and then has been designed so that each successive page reveals a different geometric shape and an animal built from it and other geometric shapes.

Illustrations and Comments

The author/illustrator's creativity is quite amazing.

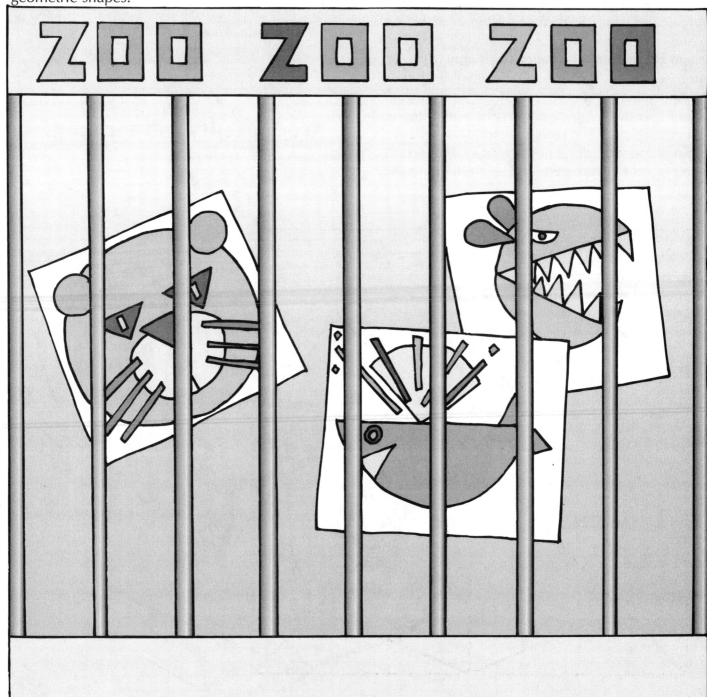

Directions

This book is not real but experienced. Discuss the shapes the students recognize and introduce the new ones. Discuss the colors and how sometimes, when complimentary colors (red/green, yellow/purple, blue/orange) are laid next to each other, they almost seem to vibrate. Discuss the animals; then show photographs or realistic paintings of animals and ask the students to tell the difference between those and the abstract animals in the book. What are the elements in the abstract animals that make them distinguishable as a particular animal? Antlers? Whiskers? Horns? Give each student a sheet of white paper and construction paper that has been cut into various geometric shapes or oaktag patterns so the students can trace and cut their own shapes. Straight-edged shapes such as rectangles, squares, triangles, diamonds, hexagons and octogons (and whiskers) can be easily cut on the paper cutter. Bright-colored 1" (2.5 cm) circular stickers are available at many discount stores, but the hearts, larger circles and ovals must be cut by hand. Now ask the students to experiment with the shapes, moving them into various positions until they have created an interesting real or imaginary animal's face. Glue. If their animal is real, have the rest of the class try to guess what it is. If it is imaginary, have the student give it an outlandish, imaginary name.

Materials

white paper 9" x 12" (23 x 30 cm)
bright-colored construction paper
scissors
glue

Art Activity

Shapely Zoo

Display

Cut 1" (2.5 cm) strips of black construction paper and attach them vertically to a white bulletin board or display area about 6" (15 cm) apart. Attach black strips measuring 6" (15 cm) wide across the top and bottom. Cut out 4" (10 cm) letters to spell "ZOO ZOO ZOO" from brightly colored construction paper, and attach them across the black strip at the top. Slide the children's animals behind the bars and staple.

68

Related Artists

Frank Stella
Piet Mondrian
Robert Indiana
Auguste Herbin, Henri Matisse, Alexander
 Calder (all of whom explored geometric
 forms to create their art)

Art Concepts and Techniques

Real animals and abstract animals
Contrasting colors
Shapes

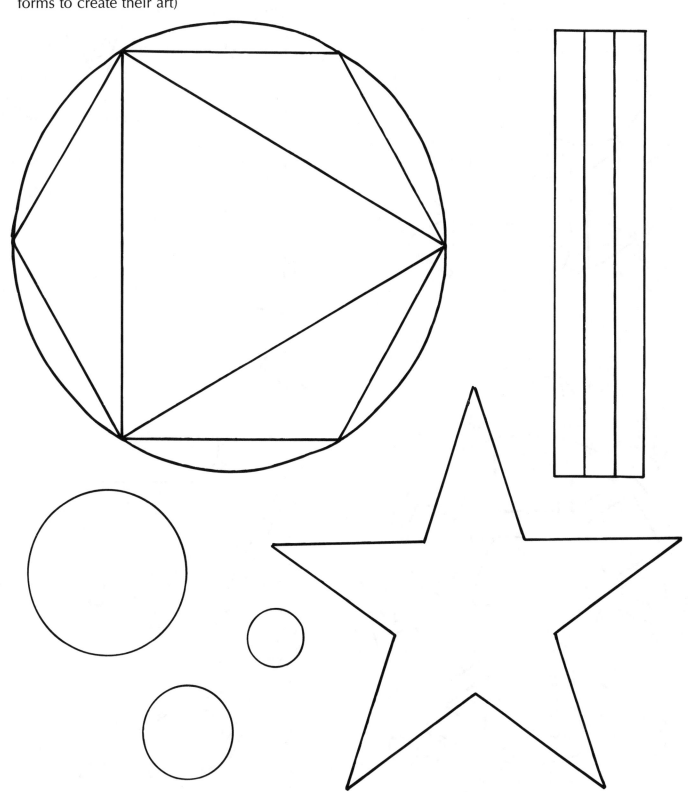

70

Black and White

Illustrated and written by David Macaulay. Houghton Mifflin, 1990. Caldecott, 1991.

Story Summary

A young boy is returning home on the night train from his first trip alone and seems to see some strange sights. A brother and sister find their usually predictable parents behaving oddly. A delayed commuter train causes would-be passengers who normally read the morning paper while they wait on the platform to engage in unusual antics. Some holstein cows get out of their field, causing "udder" chaos. These four stories progress simultaneously on the four corners of each page, yet elements of each appear in the others to form one story . . . maybe.

Illustrations and Comments

This book is truly an example of the illustrations playing such an integral part of the story that only the author could have illustrated it (or only the illustrator could have written it). The style of art is totally different in each of the four stories.

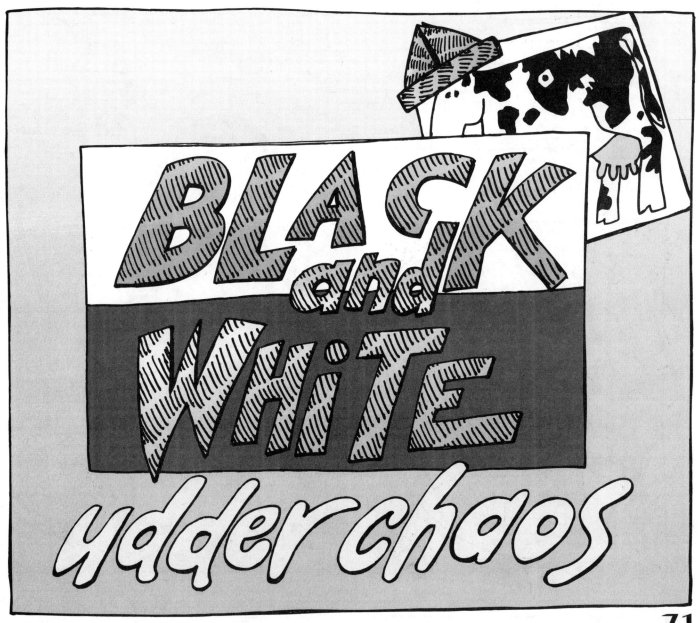

Directions

Since this book is comprised of four interrelated stories, it can be quite confusing the first time the students are introduced to it, so try reading each of the four stories separately by cutting an oaktag template the same size as the open book with one-fourth cut out so that just one of the stories is visible. The template can then be inverted or flipped to expose each story, one at a time. The students will begin to notice connections and be anxious to read the next story. When all the stories have been read, go back through the book and look at the cows. Ask the students if they have ever seen an animal whose coat had colorations that looked like a picture. Note that the hairy edges of the cow's hide can be seen in some of the illustra-tions. Using black tempera paint, have each child paint a black and white picture that could appear on a cow on a large sheet of white paper. Once the paint has thoroughly dried, use pencil to trace a cow pattern over each painting like the one shown on page 74 (may be enlarged and cut from oaktag). Each child should then make the cow take shape by painting the background (or negative space) with a bright color of tempera. Glue on a pink udder. As a final touch, give each cow a newspaper hat. Fold a half sheet of newspaper in half four times; fold the two top edges down to form a triangle; fold the brim over twice; then staple to hold. See diagram. Glue the hat onto the cow's head. Search the headlines of the leftover newspapers for letters to spell a silly name for their cow and glue those onto the finished artwork.

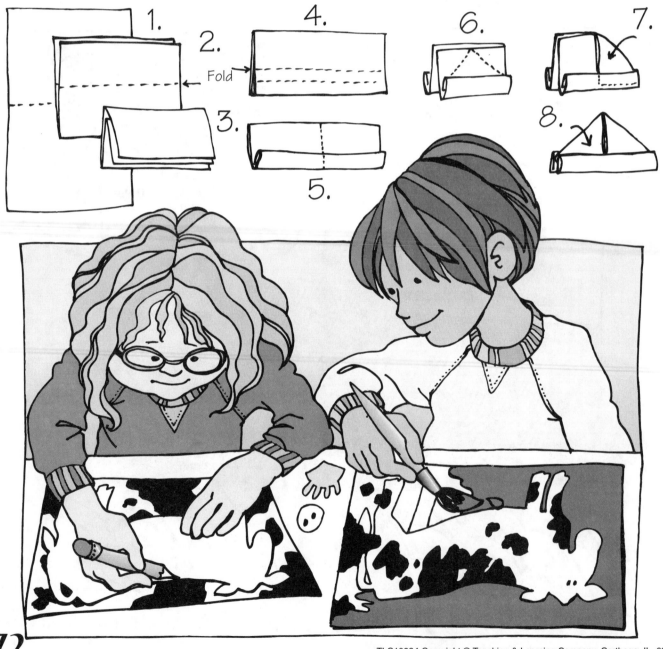

Materials

white paper 12" x 18" (30 x 46 cm)
black tempera and one other bright color
brushes
pink construction paper
scissors
old newspapers
white glue

Art Activity

"Udder" Chaos, Painting Strange Spots on Black
and White Cows

Display

Cut the letters for the title "Black and White"
from newspaper, and glue them onto black and
white construction paper. Cut small pink letters
to spell "udder chaos," and add them under the
title. Arrange the cows around the title. Spend
a little time telling "black and white and red all
over" jokes.

Related Artists

Roy Lichtenstein (heavy black outlines with
solid colors filled in)
Paul Cezanne (soft, blended colors of the boy
on train story)

Art Concepts and Techniques

Silhouette shapes
Negative space
Cutting
Folding
Painting
Gluing
Tracing

Cut from pink

Cut from pink

Tuesday

Illustrated and written by David Wiesner. Clarion, 1991. Caldecott, 1992.

Story Summary

Tuesday evening, around eight, dusk has fallen and the frogs in the ponds have closed their eyeballs for the night. Suddenly, to their amazement, the lily pads on which they sleep begin to rise into the air and fly over the town. They quickly realize that this is a good time and spend the night bombarding the laundry on the lines and driving dogs crazy. At around four in the morning, their magic "vehicles" lose their flying ability, and the frogs hop back to their pond, leaving lily pads mysteriously strewn about the town for the local detectives to ponder.

Illustrations and Comments

This unreal story is made even more absurd by the very realistic style of the illustrations. There are only about three words in the whole story. The students are expected to read the pictures, an easy task even for nonreaders.

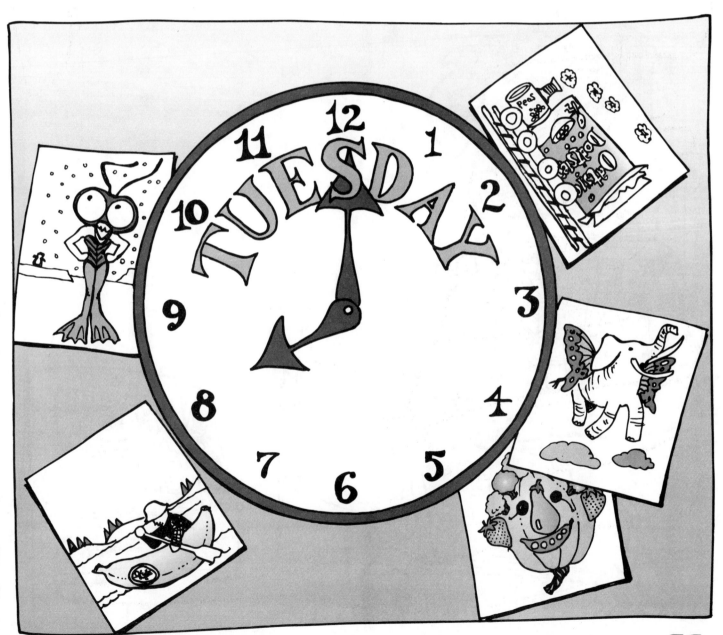

Directions

Ask the children why they think this story is funny. Every illustration contains perfectly common, realistically painted objects, yet what happens to them is totally bizarre. Discuss how they think their pets at home would react to flying frogs; then have the class suggest other ridiculous occurrences that may make their animals, or themselves, crazy. Have the class leaf through old magazines cutting out photographs of common objects and scenes; then experiment by arranging them in various uncommon ways until they get an idea for an absurd picture that they think will surprise their classmates. Glue the magazine cut-outs to the paper.

Materials

dark purple, blue or black construction paper
old magazines
scissors
glue
crayons

Art Activity

Tuesday Twilight Zone Crazy Collage

Display

Cover the display area with a brightly colored background; then cut out a white paper circle (use wastebasket for circle guide) and place it in the center. Add a 1" (2.5 cm) border around the circle with black paint, marker or construction paper. Cut out the letters to spell "Tuesday" and attach them inside the upper arc of the circle, as shown on page 75. Place construction paper clock hands radiating out from the center of the circle, pointing to eight o'clock. Place the bizarre student creations around the clock.

Related Artists

Salvador Dali (surrealist)
Edward Hopper (especially *Early Sunday Morning*)
Jan Vermeer (seventeenth century realist)
Don Eddy (twentieth century superrealist)

Art Concepts and Techniques

Surrealism
Collage
Cutting
Gluing

Tar Beach

Illustrated and written by Faith Ringgold. Crown Publishers, 1991. Caldecott Honor Book, 1992.

Story Summary

Cassie Louise Lightfoot is eight years old and lives in Harlem and she can fly. When her parents and their friends go up for supper on the rooftop, called tar beach, she and her brother Be Be lie and look at the stars in the heavens, the lights of the city and the George Washington Bridge. Cassie imagines herself soaring over them all and claiming them for her own. Her imagination allows her the freedom to go wherever she wants for the rest of her life.

Illustrations and Comments

Faith Ringgold became a children's book illustrator in an unusual way. She combined the old art of quiltmaking with painting and writing narrative and autobiography into an original art form for a series of story quilts which now belongs to the Guggenheim Museum in New York City. When she finished her work, she decided it would make a good children's book. Her work and books are often about African Americans, especially females, overcoming obstacles that race and sex have put in their way, but this book is also about a warm memory of being an eight-year-old child.

78

Directions

Once the children have heard about the happy memories of Cassie Louise's childhood, have them think of a memory they have. What do they love to do on a hot summer night? Did they ever imagine or dream they could fly? Where did they go? What other activities have they always wished they could do? Remember, in a dream anything is possible. When each student has come up with a good memory, real or imagined, have them illustrate it on a textured sheet of wallpaper, either plain or with a small print from a sample book. They should be careful not to use the outside 2½" (6 cm) or 3" (8 cm) border of their wallpaper. Now cut 2½" (6 cm) or 3" (8 cm) squares of more wallpaper samples with colorful prints on them (use the paper cutter), and give each student enough to go around the border of the artwork to simulate Faith Ringgold's story quilts in the book. You may have to adjust some measurements depending on the size of the wallpaper samples so that the "quilt" border will come out even. Be sure that no like squares are placed next to each other and that each student is satisfied with how all the pieces are placed before gluing them down. Some may need to be moved around to create the most interesting effect. Some wallpaper samples are pre-pasted and will require only moistening; others must be glued before putting into place. Once the piece has dried, use a paper punch to make holes around the outside edges. Have each student "sew" a running stitch around the border with a length of heavy yarn which has been wrapped with tape on one end so that it slides through the holes more easily. Finish the ends with a knot or bow at the top or bottom.

Materials

wallpaper samples
tempera
glue
paper punch
heavy yarn
transparent tape or masking tape

Art Activity

Dream Quilt

Display

These pieces should be displayed butting up next to each other so that they will appear to be one large quilt. Cut 10 squares from light, plain wallpaper samples. Turn them diagonally, and glue on black letters D-R-E-A-M Q-U-I-L-T, one letter on each square. Place these where the corners of the students' work come together, as shown on page 78.

Related Artists

Quilters from the past
Marc Chagall's dreamy, floating paintings

Art Concepts and Techniques

Imagining
Painting
Patterns and their combining
Gluing
Elementary stitchery

Mirette on the High Wire

Illustrated and written by Emily Arnold McCully. G.P. Putnam's Sons, 1992. Caldecott, 1993.

Story Summary

Mirette and her widowed mother run a boardinghouse in Paris that caters to the traveling players of the theater. One day a sad-faced stranger arrives and takes a quiet room. Mirette is surprised and spellbound to see him walking a tightrope one day in the backyard and begs him to teach her. He is a famous high-wire artist, but he has developed a fear of the wire. He teaches her the art, and she teaches him to master his fear. The story ends with them performing their act together around the world.

Illustrations and Comments

This story originally began as a biography of an actual high wire artist, Blondin, but lucky for us, the author/illustrator decided to incorporate the character, backdrop and artistic style of Paris in the late eighteen hundreds to create this wonderful picture book.

SECOND GRADERS ON THE HIGH WIRE

Materials

paper large enough to trace a student
pencils
tempera
markers
fabric scraps
gift wrap scraps
sparkles, ribbons, sequins, glitter (anything inter-
 esting on hand or brought from home)

Art Activity

Second Graders on the High Wire

Directions

After reading the story to the class, discuss the
requirements for walking the wire. They are the
same as those for riding a bike, rollerblading or
skiing–balance. Have a few students demon-
strate poses which require balance such as those
of Mirette or the Great Bellini in the book. Now
have the students working in pairs or small
groups, trace each other in a balancing, wire-
walker's pose onto large sheets of white or
brown paper. Add facial features by measuring
the size and location of the student's and trans-
ferring these measurements on the tracing.
Dress the figure in a suitably creative costume
using bright colors of tempera, markers, fabric
scraps, sparkles, ribbons, sequins and glitter.
Cut out the finished products.

Display

String a dark piece of yarn horizontally, halfway
up the wall of a long hallway, and use loops of
masking tape to adhere the figures to the wall so
that they appear to be balanced on the yarn.
Cut out letters from pink construction paper to
spell the title "Second Graders on the High
Wire" and outline them in black. Attach them
to the wall just below the "wire."

Related Artists

Pierre Auguste Renoir
Edouard Manet
Henri de Toulouse-Lautrec
Edgar Degas

Art Concepts and Techniques

Balance
Placement of facial features
Creative design (of costume)
Drawing
Cutting
Gluing

Seven Blind Mice

Illustrated and written by Ed Young. Philomel, 1992. Caldecott Honor Book, 1993.

Story Summary

The story is an old familiar one–seven blind mice encounter a strange "something" by their pond. Each day of the week one mouse sets about to find out what it is and because each explores a different portion, each arrives at a different conclusion. At last, the seventh mouse runs up one side and down the other, across the top and end for end and proclaims it to be (you guessed it) an elephant!

Illustrations and Comments

Ed Young is a Chinese artist who has used ancient Indian folklore as inspiration for this tale. All the backgrounds are dark, shiny black, and each blind mouse is a different vibrant color who sees the "something" as being the same color as himself. The elephant is created from a rough, handmade paper, all wrinkly and gnarled–perfect!

1. Apply coat of thinned white glue.

2. Lay on paper towels and dryer sheets.

3. Sprinkle dirt and brush in.

Directions

Once the story has been enjoyed, ask the students why they think the artist chose not to put in more background details. Would it have just cluttered it up? Can you still understand the important parts of the story? The Chinese feel that what an artist chooses to leave out is as important as what is included. Can the class tell that the Chinese illustrator of this book was influenced by the art traditions in his native country? Now take a closer look at the elephant. Have the students guess how the artist made the interesting texture. Though the pages of the book are smooth, the original artwork would have felt very bumpy. Demonstrate how the students can create a piece of "elephant paper" by painting a quarter sheet of newspaper (no colored sections) with watered-down white glue, then laying recycled crumpled paper towels (use only towels that have dried clean hands) over the newspaper and applying another coat of thin glue. Be sure to leave in some wrinkles and creases to create the best texture. In some areas, repeat the process using a used, white dryer sheet. While the work is still wet, sprinkle a tiny bit of dirt over it and blend it into the cre-

ation. Be sure that the brushes are washed immediately. When this "elephant paper" is dry, spread a large sheet of white butcher paper (bulletin board size) on the floor, and sketch an elephant shape onto it as large as possible. Have the students glue their elephant paper inside the lines so that one large, bumpy beast results. Trim the edges that overlap, and use the scraps to fill in any holes. Cut tusks from white and an eye from black paper, and glue them into place.

Materials

recycled paper towels
old newspapers
tracing paper or other thin paper or used
 fabric softener dryer sheets
dirt
watered white glue
paintbrushes
white and colored paper

Art Activity

Elephant Paper Elephant

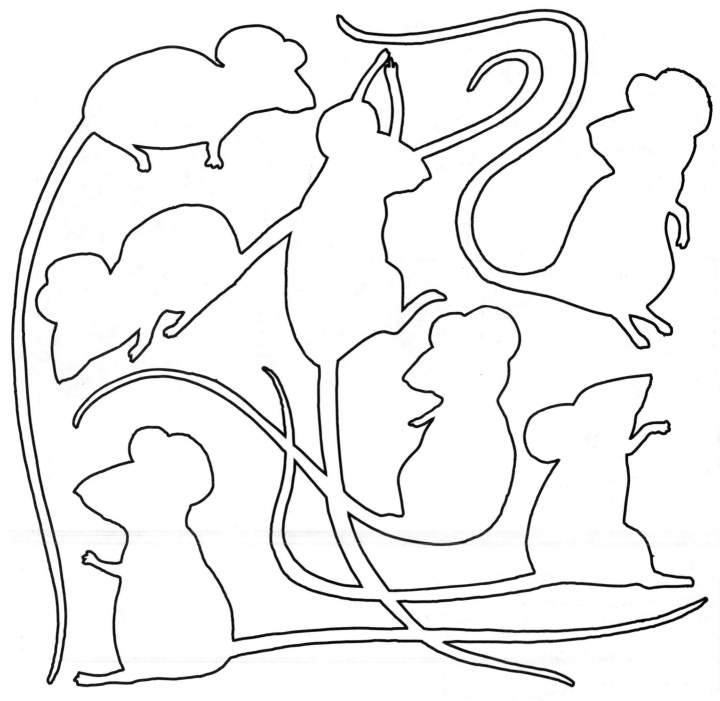

Display

Cut out the elephant and mount him on a black background or tape him to the wall with his feet touching the ground. Cut out seven tiny mice, one of each color in the story, and tape them on the elephant where they originally explored it. Cut out letters to spell "The Strange Something" using white or colored paper, and add it on or above the elephant.

Related Artists

Chao Shao-ang
Hsu Pei-hung (Ju Peon)
Wang Ch'eng-p'ei (or any other example of minimalist Chinese painting)

Art Concepts and Techniques

Texture
Color
Shapes

87

Yo! Yes?

Illustrated and written by Chris Raschka. Orchard Books, 1993. Caldecott Honor Book, 1994.

Story Summary

This story of very few words is about making friends. They greet, establish that they are both looking for something to do and someone to do it with, then decide that they will choose each other. Conversation is only minimally necessary when two kids have an understanding.

Illustrations and Comments

The illustrations are also simple–just the two boys sketched with crayon in solid, simple lines and painted in with watercolor in various poses. Their expressions take up the conversation where the words leave off. There are no backgrounds, except some soft areas of color, but the bold words on each page are part of the art.

Directions

Once the class has enjoyed the story, have them tell the story that the pictures tell, and discuss how sometimes just one word can say a lot. How does the size and color of the word on the page help to confey its meaning? Brainstorm about some joyful words such as *Yow! Wow! Awesome! Great! Joy!* Write them down as each one is suggested. Be sure to use an exclamation point! Now look at the pictures and talk about the artists cartoon style. It may remind the children of Charlie Brown. They can see that the artist used heavy black crayon to draw very few, very simple lines, then paint in the details with solid areas of color. Divide the students into pairs, making sure that no two best friends are together as this is an activity about making new friends. Have each child draw his partner in a joyous jumping pose like the last one in the book on one half of the paper in the simplified cartoon stylse used by the artist. Fill in the clothing and other details with as few simple crayon lines as possible, and then paint the figures with watercolor,w hich will not smear or cover up the crayon. Have the pair decide on a joyful word to write in fanciful letters across the top of the finished picture.

Materials

large white paper 18" x 24" (46 x 61 cm) or so
black crayons
watercolors
brushes

Art Activity

Yo! Yes? Yow! Mixed Media Pal Painting

Display

Using black crayon applied in heavy lines, write the words *Jump for Joy* as shown on page 88. Paint them in a joyful way with watercolors, and display it above the jumping figures.

Related Artists

Charles Schultz
Pablo Picasso

Art Concepts and Techniques

Cartoon style
Words written as part of the finished art

In the Small, Small Pond

Illustrated and written by Denise Fleming. Henry Holt, 1993. Caldecott Honor Book, 1994.

Story Summary

This story is a clever, simple rhyme (carefully chosen words per page) about the animal life in a small, small pond, from whirlygigs to muskrats, as seen through the eyes of a frog who hops from page to page. In the end, the frog is asleep in the mud, hibernating for the winter.

Illustrations and Comments

These simple-looking illustrations are achieved by using a complex papermaking process. Colored cotton paper pulp is poured over stencil forms, and the water is gently pressed out leaving paper that is already art!

To Gram:

From a Small Small
Jessica

Directions

Read the story through and then go back and look more closely at the illustrations. It is very difficult to guess how the artist did them, but explain that they were made in the same way that paper is made only with the paint added before instead of painted on after as usual. Demonstrate how to make paper by tearing scraps of recycled paper to fill a blender about half way, then adding enough water to cover it and blending until it is pulp. Now add a spoon of powdered green and blue tempera and blend again. Set the picture frame screen inside the flat pan and pour the blended pulp over it spreading it with fingers until it is evenly distributed. Lift the frame up, holding it over the pan to allow excess water to drain off; then lift it onto several layers of newspaper. Dab the pulp gently with the sponge until it is only damp; then turn it over onto dry newspapers and set aside to dry. Paper should be thicker than regular paper, like cardboard, to be sturdy enough. Have students take turns making their own piece of paper, tearing scraps while they wait. When paper has dried thoroughly, have each student make a pond animal such as those in the story or others they may know, using construction paper and crayons or oil pastels. Cut it out and glue it to their homemade paper. Hot glue googly eyes to add a great finishing touch. Mount these with hot glue or white glue onto pieces of matt board cut on the paper cutter about 1" (2.5 cm) larger than the handmade paper all around.

Materials

recycled paper in shades of white, blues and greens only
blue and green powdered tempera
old blender
old 5" x 7" (13 x 18 cm) wooden picture frame with screening stapled to replace the glass
flat pan which is a few inches (centimeters) larger than the frame
newspapers
flat sponges
construction paper
crayons or Craypas™
googly eyes from craft store

Art Activity

Small, Small Poured Paper Ponds

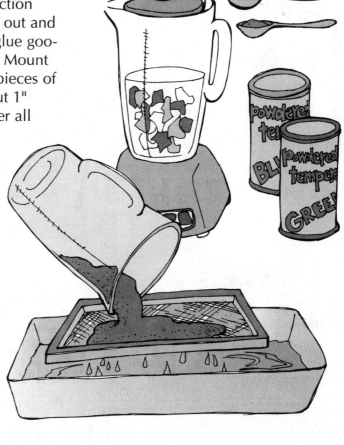

old picture frame

Dab with sponge

Remove screen

Display

Glue a triangle of matt board to the back of the pictures so that they stand by themselves. Send them home as gifts for a favorite aunt or grandparent.

Related Artists

Wassily Kandinsky (compare vibrant playful colors and shapes)

Art Concepts and Techniques

Papermaking (ancient art form and modern twist)